POSTCARD HISTORY SERIES

Winona

IN VINTAGE POSTCARDS

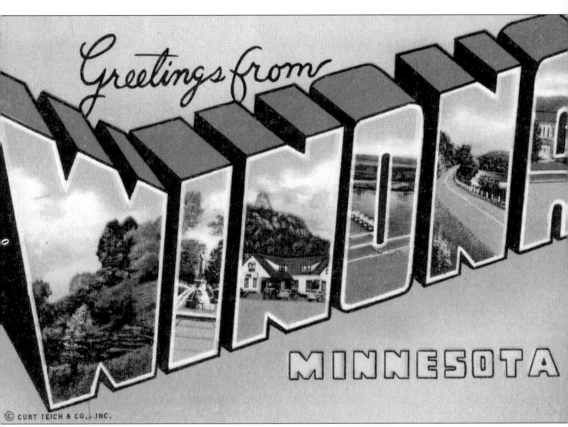

Hundreds of large letter postcards were produced between 1933 and 1956 by the Curt Teich Company. The Winona large letter postcard shown above is a typical example of the style. Winona scenes are contained within the letters: W—Indian Head, I—Princess Wenonah Statue, N—Hot Fish Shop at Sugar Loaf, O—Whitman Dam, N—Scenic Drive, and A—College Building.

POSTCARD HISTORY SERIES

Winona

IN VINTAGE POSTCARDS

Chris Miller and Mary Pendleton

ARCADIA

Published by Arcadia Publishing,
an imprint of Tempus Publishing, Inc.
Charleston SC, Chicago, Portsmouth NH,
San Francisco

Printed in Great Britain.

Library of Congress Catalog Card Number: 2003115860

For all general information contact Arcadia Publishing at:
Telephone 843-853-2070
Fax 843-853-0044
E-Mail sales@arcadiapublishing.com
For customer service and orders:
Toll-Free 1-888-313-2665

Visit us on the internet at http://www.arcadiapublishing.com

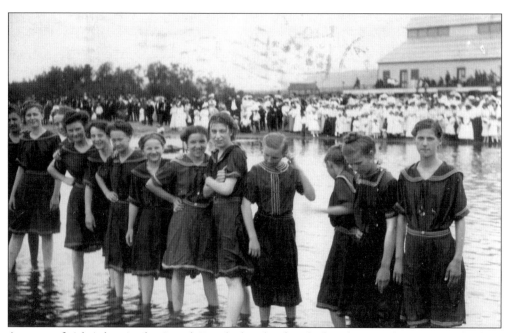

A group of girls is baptized at Latsch Beach shortly after the beach opened in 1908. Onlookers dressed in their Sunday best line the shore behind them.

CONTENTS

ACKNOWLEDGMENTS

Publishing this book would not have been possible without the assistance of Mark Peterson of the Winona County Historical Society, and also "sadsack," "tedfoo," and "Neilix" of www.winonanet.com who were willing to provide answers to questions. The following people also provided help with research and with getting this project going: Barbara Timm, Dale Ebersold, Bill Spitzer, Dan Grossell, Debra Bricault, Bill Kuhl, John Goplen, Mary Nankivil, Sonja Childs, Mark Hammonds, Jerome Christenson, and our patient editor Maura Brown.

The following provided permission to reprint their photographs, artwork, or other material in this book: John Durfey, Verda Goetzman of Universal Photo Service, the Winona County Historical Society, Alf Photography, the G.R. Brown Postcard Company, Winona Printing Company, the Curt Teich Archives, American Trapshooters Association, Mary Nankivil, Kay Shaw, Dick Swift, Gayle Goetzman, Happy Chef Systems, Jim Bambenek, Jim Galewski, and Audio Visual Designs (P.O. Box 377, Herkimer, New York 13660-0977).

This book is dedicated to the memory of Paul Henry Miller, and of George and Ada McLeod Engstrom.

INTRODUCTION

The earliest known evidence of human habitation in the Winona area was the rock shelter near La Moille, south of Winona. Petroglyphs and other evidence of the Woodland people, dating to at least 600 years B.C., were found at this site. When French explorers arrived in the 1600s, the Mdewakanton band of the Eastern Dakota resided in the area, maintaining a camp on a large sandy island on the Mississippi River. The island was called Prairie Aux Aisle ("Prairie with Wings") by the French and Sand Prairie by the rivermen. It was known as Keoxa ("the Homestead") to the band of Mdewakanton led by Chief Wapasha II and his successor, Chief Wapasha III, and later called Wabasha's Prairie before it took its current name of Winona.

The tide of American settlers reached southeastern Minnesota in the mid-19th century, and similar to events earlier in the East and later in the West, the Dakota and other native people in the area were relocated westward, sometimes forcibly. Keoxa was replaced with the new territorial town of Winona.

Winona's "Gate City" location between the East and the newly-opened lands to the west, combined with the heavy Mississippi River traffic of the era, resulted in the city's "Golden Age" during the last third of the 19th century. While there was a strong industrial base and a variety of Winona products of national importance—from wheat to wagons to Watkins—the lumber industry was dominant.

With the collapse of the lumber industry at the end of the century, Winona's "Golden Age" ended and the explosive growth halted; the goal of a population of 50,000 some hoped for would never be reached, while it would be reached by the neighboring cities of Rochester and La Crosse.

Winona was able to start the 20th century with many attributes: a diverse population, including large communities of settlers from Poland and other countries, a strong educational base, industries such as Watkins and Bay State Milling, natural beauty, and a wealth of now-historic buildings.

The postcard era began after Winona's golden age. While the postcards do not document Winona's golden age, except for a few that feature very old photos, the postcards of the 20th century document Winona's continuing development as a thriving community at work, at school, at play, and at worship.

Although postcards had been around previous to 1907, changes in policies of the United States Postal Service that year resulted in a golden age of postcards, as millions were sold and used leading up through 1914. This is the period that generated most of the oldest postcards in this book.

Until the photochrome cards started to come out in the late 1940s, printed postcards were divided between the real photo postcards, which resembled black and white photographs, and

the less-photorealistic lithograph postcards. In Winona, the studios of Frey and Cutler produced real photo postcards, and Jones and Kroeger was one of the companies printing lithographic postcards. At mid-century, many linen postcards were produced, featuring a cloth-like finish and often garish colors.

The linen era gave way to the era of the photochrome postcard, which has continued to this day. Universal Photo Service of La Crosse and the Oliver Durfey Studio of Winona were major producers of postcards during the early part of the chrome era in the 1950s and 1960s. The chrome cards are almost all in color, and photographic in appearance, but are not photographs (being printed with a process similar to that used to make color magazine pages). Drawing mostly from the collections of the authors, this book features a variety of postcards of all these types, from all of these eras, depicting Winona and the surrounding area. A few other non-postcard images of interest are also included.

This very old postcard, likely from around 1907, presents views of Winona. Depicted from top to bottom, right to left (row by row), are the following: Levee Park, General Hospital, library (in oval in center), high school, Normal School, downtown, Third Street, Hotel Winona, Courthouse, and post office.

One
KEOXA

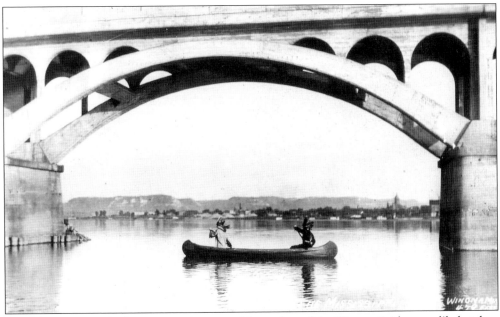

This photo postcard of a canoe under one of the arches of the Wagon Bridge was likely taken in the 1920s in association with the Water Carnival. The Dakota had almost all departed from the Winona area by the early 1850s, so the costumed men on this postcard are probably not members of the Dakota tribe. Before 1850 Winona was the Mdewakanton Dakota (Sioux) camp known as Keoxa, but by the 2000 census, the number of persons claiming to be Native American of any kind in Winona County was a mere 0.2 percent.

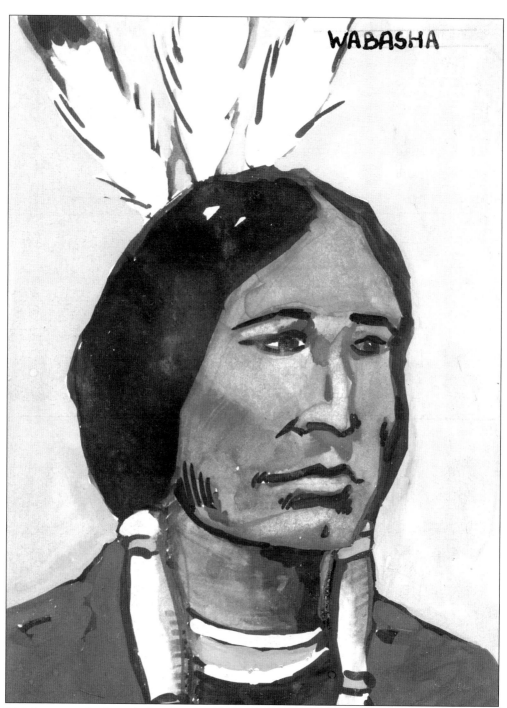

WABASHA

This is an actual color painting the size of a postcard, rather than a postcard print of a painting. Chief Wapasha III (1816?–1876) was born in Keoxa (later Winona), where he lived until he was forced to move west. The name meant "Red Leaf" or "Red Banner," and is also spelled "Wabasha" (along with many other variations). Chief Wapasha III is buried at Hobu Creek Cemetery in Knox County, Nebraska.

This painting of Princess Wenonah on Lake Pepin looking up at Maiden Rock is from a vintage Watkins Incorporated advertising booklet entitled "Wenonah: The Story of an Indian Maid." In the legend, the Princess Wenonah (who is from Keoxa) leapt to her death rather than face an unwanted pre-arranged marriage. Wenonah is a common name that means "first-born daughter" in the Sioux language. The woman the city of Winona was named after (a non-legendary close relative of Chief Wabasha III, probably his sister) was certainly different from this legendary figure, but in the popular imagination the two are sometimes assumed to be the same woman. The "princess" concept is an embellishment of the tale told by white settlers. There are several variations of this legend.

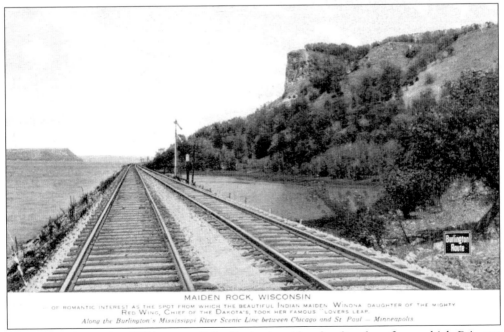

MAIDEN ROCK, WISCONSIN

OF ROMANTIC INTEREST AS THE SPOT FROM WHICH THE BEAUTIFUL INDIAN MAIDEN WINONA DAUGHTER OF THE MIGHTY RED WING, CHIEF OF THE DAKOTA'S, TOOK HER FAMOUS "LOVERS LEAP.

Along the Burlington's Mississippi River Scenic Line between Chicago and St. Paul — Minneapolis.

Maiden Rock, north of Winona on Lake Pepin, is said to be the place from which Princess Wenonah leapt to her death. This postcard from 1923 promotes Maiden Rock as one of the attractions of the Burlington Route, and it mentions the legend.

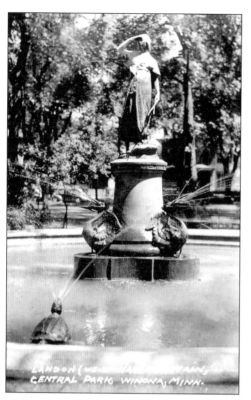

The Princess Wenonah statue, shown here at its first location, was sculpted by Isabel Moore Kimball. Initially placed in Central Park in 1902, she was moved to different locations in Winona before arriving at her current location in Windom Park. The statue commemorates the princess of the Maiden Rock legend.

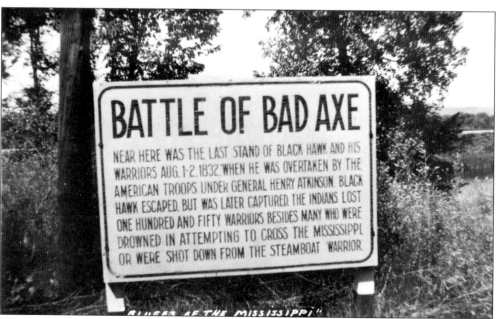

BATTLE OF BAD AXE

NEAR HERE WAS THE LAST STAND OF BLACK HAWK AND HIS WARRIORS AUG. 1-2, 1832, WHEN HE WAS OVERTAKEN BY THE AMERICAN TROOPS UNDER GENERAL HENRY ATKINSON. BLACK HAWK ESCAPED, BUT WAS LATER CAPTURED. THE INDIANS LOST ONE HUNDRED AND FIFTY WARRIORS BESIDES MANY WHO WERE DROWNED IN ATTEMPTING TO CROSS THE MISSISSIPPI OR WERE SHOT DOWN FROM THE STEAMBOAT "WARRIOR."

This postcard from the "Bluffs of the Mississippi" series depicts the historical marker at the Bad Axe River, some 20 miles south of La Crosse. This 1832 battle marked the defeat of Chief Blackhawk and his people. Chief Wapasha II and his warriors came down from Keoxa (Winona) and fought against Chief Blackhawk on the side of the white soldiers.

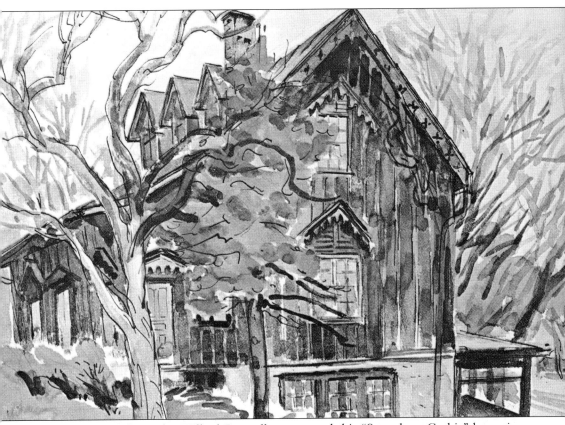

During the 1850s, fur trader Willard Bunnell constructed this "Steamboat Gothic" home in an area near Homer known as Minneowah (just east of Winona). His friend Chief Wapasha III granted him permission to settle here. James Reed, the founder of the town of Trempealeau, helped him build his homestead. Now maintained by the Winona County Historical Society, the house is open to the public. Postcards of the house were only printed in recent decades after the house became a museum. The painting printed in this postcard was made by Jo Lutz Rollins. (Courtesy of the G.R. Brown Postcard Company.)

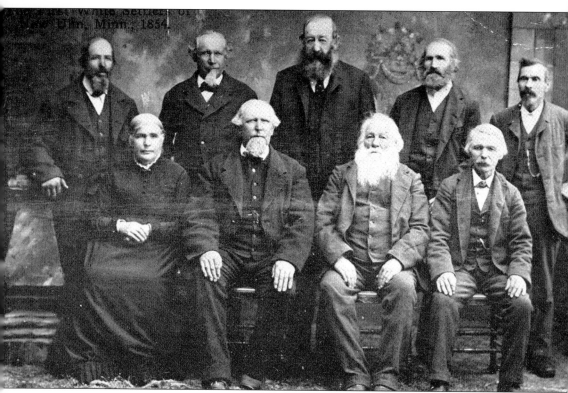

This postcard published around 1910 shows a group of settlers in New Ulm in central Minnesota *c.* 1854. This was a time when white settlers were also flooding into the Winona area, due to a treaty which opened up much of the Sioux (Dakota) land to white settlement in 1851. During the Dakota Uprising of 1862—which affected much of central and southwestern Minnesota—New Ulm was evacuated, and refugees temporarily swelled the populations of towns including Winona, which were outside of the battle area. Chief Wapasha III participated in this uprising somewhat reluctantly.

Two
WINONA FROM ABOVE

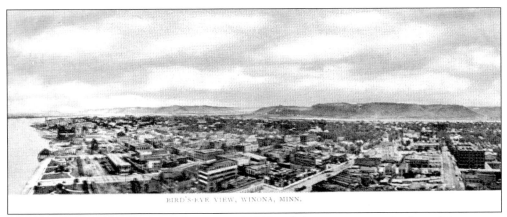

BIRD'S-EYE VIEW, WINONA, MINN.

This postcard was printed between 1901 and 1907 and shows a panoramic view of the eastern half of Winona from above. Levee Park is on the left and the Winona Hotel is on the right. Sugar Loaf is the bluff in the distance above the comma after the word "Winona." Many birds-eye view postcards of Winona were created from photographs taken from blufftops (such as Garvin Heights), the standpipe (water tower) on the riverfront, or from airplanes.

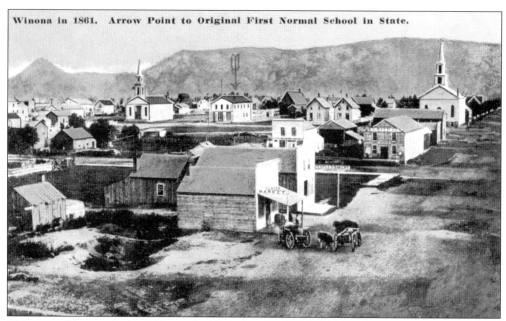

This very old view depicts Winona in 1861, the year before a fire devastated much of the city. The small Normal School building is shown below the arrow at center. The Center Market and People's Bakery are in the foreground, and Sugar Loaf stands in its original form on the left.

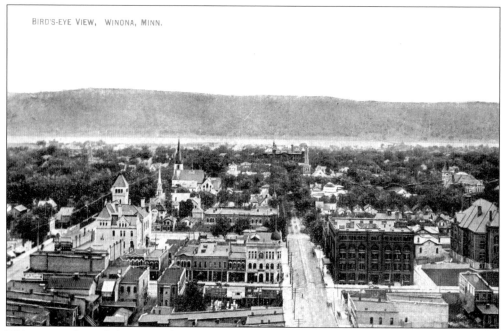

This postcard (mailed in 1912) looks south down Johnson Street to where it ends at the main building of the Normal School. Many of the large buildings seen here—such as the Schlitz and Winona Hotels to the left and right of Johnson Street—are still standing as of 2003. The post office, on the left, and the Normal School building are two that did not last.

16

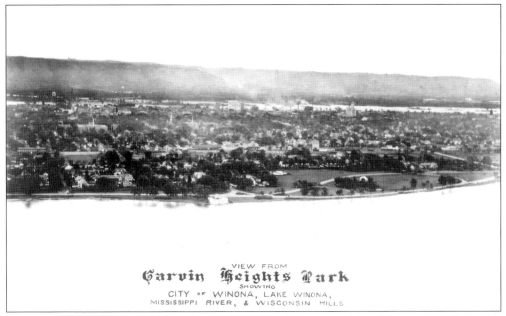

VIEW FROM
Garvin Heights Park
SHOWING
CITY OF WINONA, LAKE WINONA,
MISSISSIPPI RIVER, & WISCONSIN HILLS

This view from Garvin Heights shows downtown Winona and the Wisconsin hills in the background, and the eastern part of Lake Winona in the foreground, with Lake Park and the bandshell (the white arch) seen at the shore. Views of the city from Garvin Heights are popular with postcard makers.

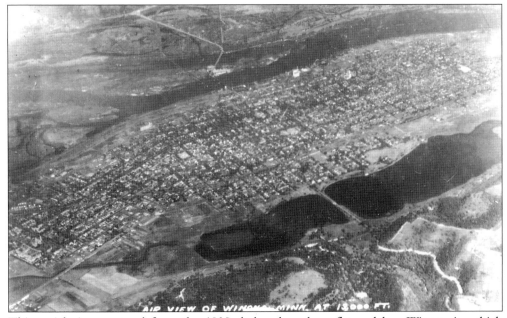

AIR VIEW OF WINONA, MINN. AT 13,000 FT.

This aerial view postcard from the 1930s helps show how flat and low Winona is, which demonstrates its vulnerability to Mississippi floods. The photo was taken over the area of St. Mary's College and looks toward the northeast.

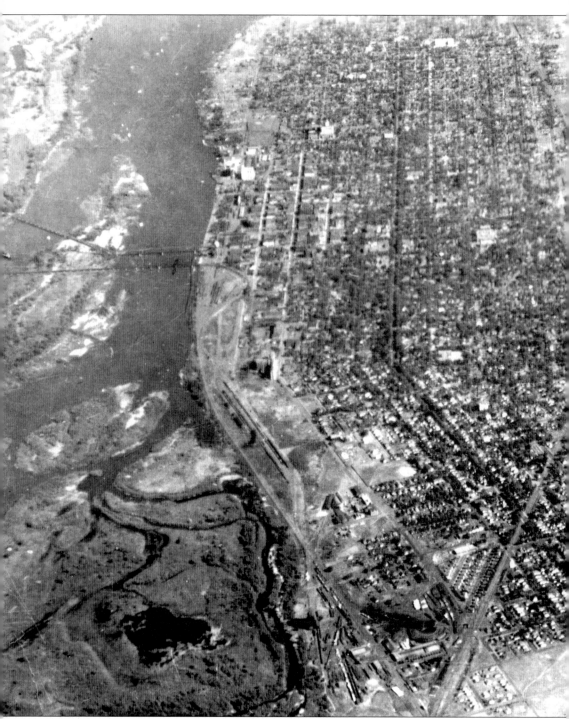

This postcard from the 1930s shows an aerial view of Winona from west (bottom) to east (top) and from an altitude of 16,000 feet. Among the things evident here are the lack of buildings at the east end of Lake Winona (upper end of photo), the marshiness of the western half (lower end of photo), and the open fields to the west of the College of St. Teresa. The

main east-west highway through town goes along Gilmore Avenue in the photo (to the left of the lake), and the current location of Highway 61 (to the right of the lake) is occupied at the time of the photo by the Chicago and Great Northwestern Railroad.

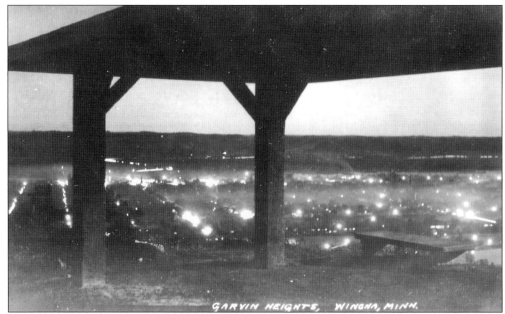

This photo postcard shows the lights of Winona from the Garvin Heights viewpoint at night. In the days before air conditioning, Winonans would sometimes come up here to sleep at night, cooled by the breezes that blew across the blufftops.

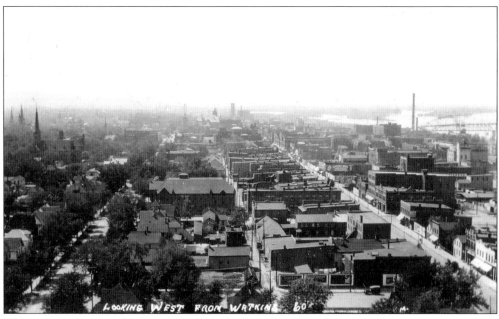

This postcard, printed between 1907 and 1914, shows a view toward downtown, looking west from 60 feet up in the Watkins buildings. Churches (including Central Methodist and First Congregational) are on the left, the High Wagon Bridge is on the right, and the courthouse is in the back center.

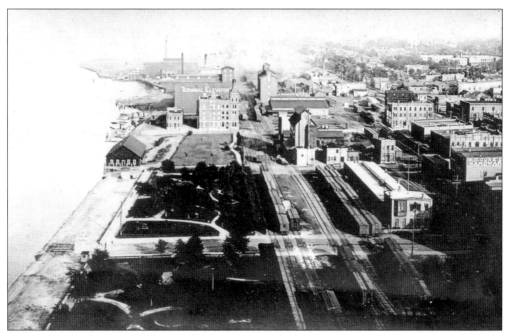

The photo printed in this postcard, *c.* 1908, was probably taken from the standpipe (a brick water tower). The elaborately-landscaped Levee Park is in the foreground, and the industrial area including Bay State Milling lies beyond. The downtown area is on the right.

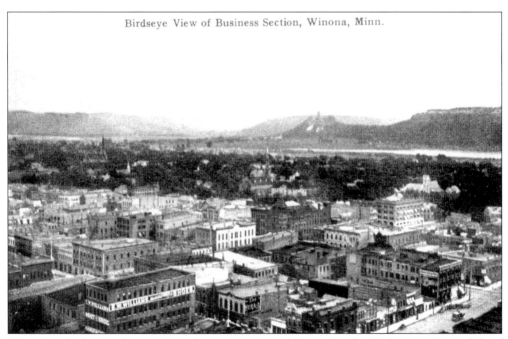

This view looks southeast across downtown toward Sugar Loaf, which is wearing a bib of quarrying rubble that is not yet overgrown. Visible in the foreground are the Williams Shoe Company and the Winona Herald building (at right).

21

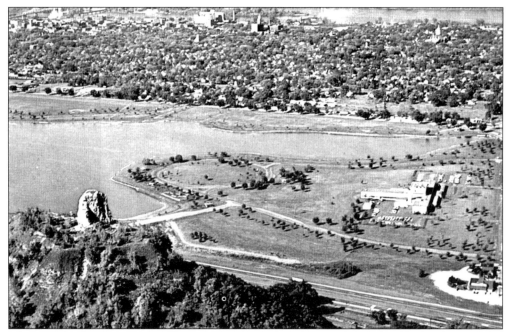

This aerial chrome postcard from *c.* 1970s shows the southeast corner of Winona. The Interstate Bridge is in the upper left, St. Stan's is in the upper right. The Hot Fish Shop is in the lower right (with the hospital nearby), and Sugar Loaf is in the lower left. The Hot Fish shop has since been replaced by a Dairy Queen and other new construction. (Courtesy of the G.R. Brown Postcard Company.)

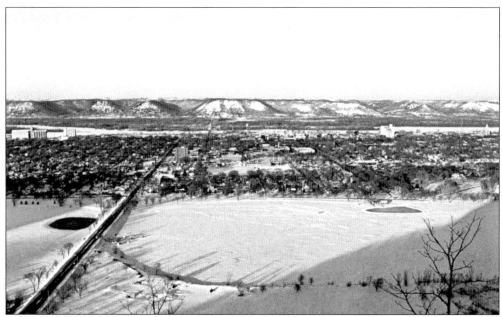

This Garvin Heights view from the mid-1970s shows Lake Winona frozen in winter, and the snow-covered Wisconsin bluffs in the distance. A few ice shanties are near the fishing pier to the right of Huff Street, which divides Lake Winona. (Courtesy of Dick Swift.)

Three
SUGAR LOAF AND
THE BLUFFS

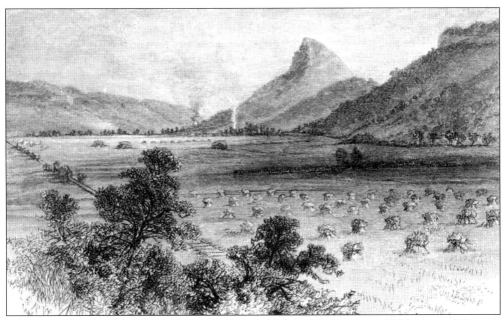

This artist's view of the intact Sugar Loaf was published in the June 1883 issue of *Harper's Monthly* magazine. There are two common misperceptions about Sugar Loaf: one is that it was only named Sugar Loaf after being altered, the other is that its current appearance reflects a natural formation. The earlier name of Sugar Loaf was Wapasha's Cap, due to its resemblance to a hat worn by one of the Wapasha chiefs.

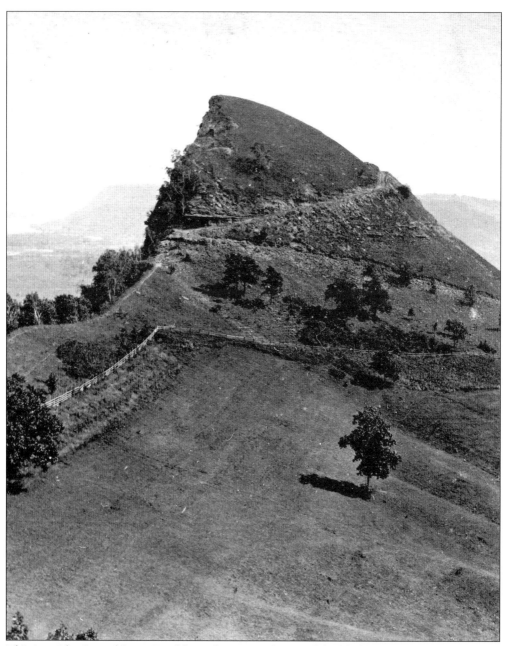

This is a side view of Sugar Loaf from the point of view of the bluff immediately to the west. It is from a stereoview, likely from the 1880s, taken by W.H. Illingworth, who accompanied and photographed General George Custer's 1874 expedition into the Black Hills.

In this picture the bluff is unquarried, but there is a road zig-zagging up the side of it. During the 1880s, most of the top of Sugar Loaf was quarried off by brothers John and Stephen O'Dea. Citizens eventually urged the brothers to stop the operation, so they neatened up what remained and stopped quarrying in 1887.

This postcard, mailed in 1914, shows an artist's view of a pine tree-covered Sugar Loaf, looking much steeper than it actually is. The effect is that of a Mayan temple in the jungle.

This leather postcard depicting Sugar Loaf was mailed in 1907 from Winona. Leather postcards date to the years 1904 through 1908, after which they were banned by the U.S. Postal Service.

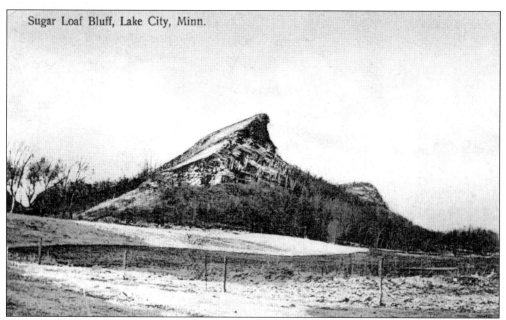

Sugar Loaf Bluff, Lake City, Minn.

Sugar Loaf in Winona is not the only Sugar Loaf in the world. There are many other famous ones in places such as Michigan, Wales, Rio de Janeiro, the Hudson River Valley in New York, and the Catalina Islands off of California. There are even two others not far from Winona: the one behind Lake City depicted in this 1942 postcard, and one near La Crosse.

This view of Sugar Loaf with Lake Winona as its reflecting pool is a common image in postcards from various years. Little has changed: a few more buildings line the feet of the bluffs, and trees continue to gain a foothold in the bare rock and rubble of the bluff.

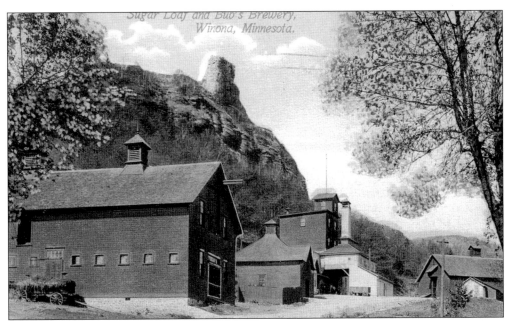

Sugar Loaf and Bub's Brewery, Winona, Minnesota.

In 1870, Peter Bub came to Winona and took over a brewery which had been established in 1856. Bub (which rhymes with "tube") had worked at the Blatz Brewery in Milwaukee. The brewery, nestled into the side of Sugar Loaf, operated until the 1960s. The brewery building was most recently a furniture store. A tavern in downtown Winona on Fourth Street bears the Bub's name today.

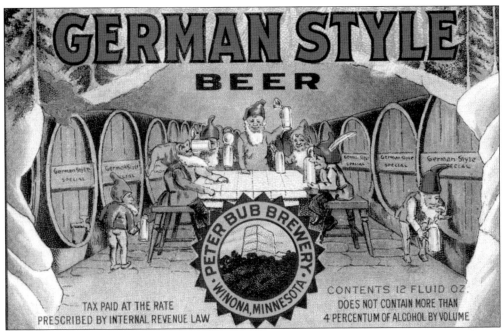

This 1933 Bub's beer label shows gnomes enjoying the brew. Sugar Loaf is featured on the seal on the center, and it was also featured on other Bub's labels and cans. Bub's items are highly collectible today, especially the cone-top beer cans.

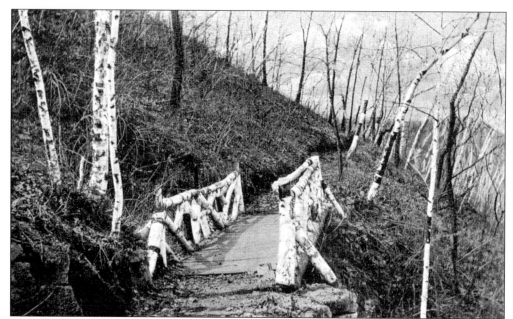

This postcard shows Birch Trail, one of the many trails that wind through the bluffs which lie to the south of Winona.

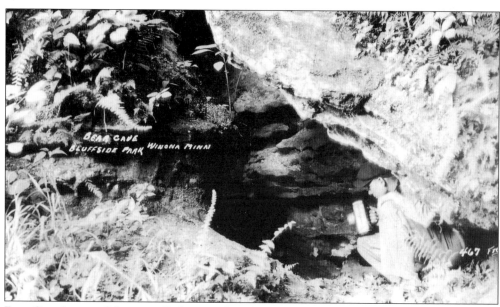

Bear Cave is one of the many little caves found in Bluff Side Park, located on the south edge of the city, west of Woodlawn Cemetery. While bears could have frequented this location in the past, they are not known to range south of Anoka County (far to the north) at this time.

28

This postcard shows Devil's Cave with a bench in front of it. An incident in Devil's Cave involving Rev. Edward Borncamp of St. Paul's Episcopal Church is described in the *Winona Republican-Herald*, 1903: "Mr. Borncamp had no candles with him, and on getting on the inside, it took him some time to get accustomed to the light. As soon as he had done so, he detected two glaring eyeballs in one corner and at once came to the correct conclusion that a wolf was in the cave. Not being armed, he naturally did not care to face an encounter with the beast and so prudently beat a retreat."

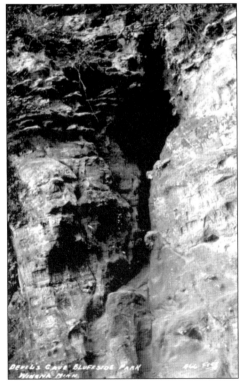

Devil's Cave is reachable by hiking past the Stone Circle in Bluff Side Park. It is entered through a vertical crack in the rock face of the bluff.

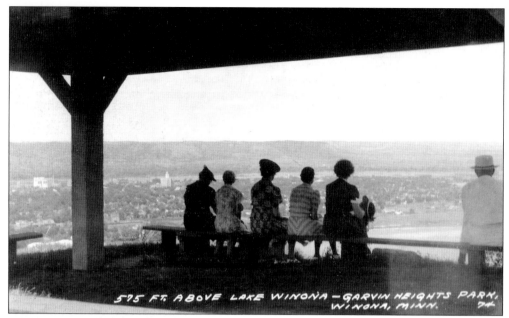

Garvin Heights Park was donated for public use by Herbert C. Garvin of Bay State Milling Company in 1922. The pavilion seen in this postcard is no longer there, but the park is still a treasure along this stretch of the Mississippi River, and from it you can see for many miles on clear days.

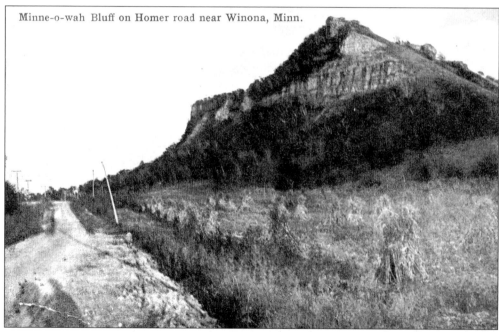

Minne-o-wah Bluff on Homer road near Winona, Minn.

Mt. Minneowah at Homer, just east of Winona, has also been called Government Peak. Camp Minneowah used to be located at its base. It is found in the group of bluffs downriver, east of Sugar Loaf.

Indian Head is a rock formation located on Highway 35 in Wisconsin between Winona and Fountain City. This formation has been featured on several different postcards over a period of many years. It can only be seen coming from the southeast, driving from Winona to Fountain City.

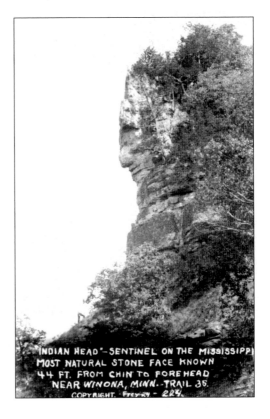

"INDIAN HEAD"—SENTINEL ON THE MISSISSIPPI
MOST NATURAL STONE FACE KNOWN
44 FT. FROM CHIN TO FOREHEAD
NEAR WINONA, MINN.-TRAIL 35.
COPYRIGHT. Frey·R⁴ - 224.

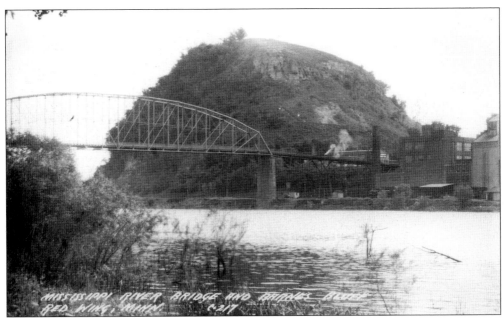

MISSISSIPPI RIVER BRIDGE AND BARNES BLUFF
RED WING, MINN.

Barn Bluff is located in Red Wing, north of Lake Pepin. In Dakota legend, Red Wing's Barn Bluff is linked to Winona's Sugar Loaf; the story states that the bluffs were once combined, and then sundered as the result of a conflict.

King's Bluff (right) and Queen's Bluff (left) are the central features of Minnesota's Great River Bluffs State Park southeast of Winona. They are easily seen from the north on Highway 61 (and from across the river). The park features a trail up King's Bluff, which affords views of the river valley.

Queen's Bluff looks similar to how Sugar Loaf in Winona looked before it was quarried. In *Life on the Mississippi*, Mark Twain quotes a fellow passenger describing Queen's Bluff as "just as imposing a spectacle as you can find anywhere." (Courtesy of Verda Goetzman.)

Four
BOATS, BEACHES, AND BRIDGES

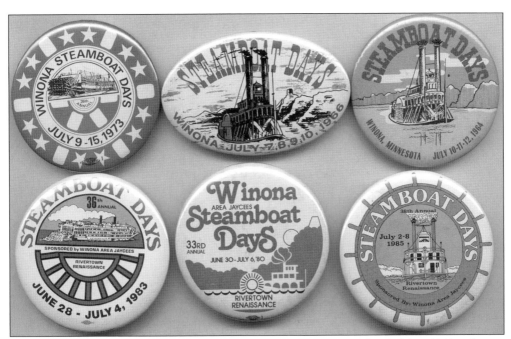

Steamboat Days, Winona's great annual summer celebration, was first held in 1948 to honor the rivermen who piloted the Mississippi steamboats. Over the years the many festivities have included parades, band concerts, boxing matches, races, and a carnival.

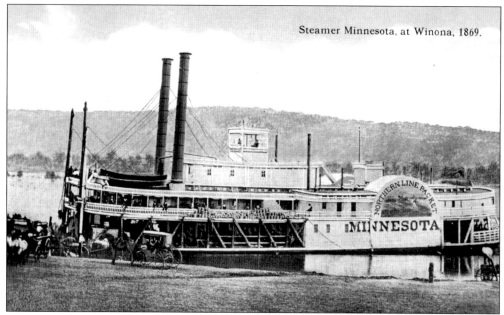

Steamer Minnesota, at Winona, 1869.

This lithographic postcard from shortly before 1916 makes use of a photograph from 1869. A typical cargo for the *Minnesota* (this example delivered in 1867 at the Burlington, Iowa, levee) included 389 packages of lead, one barrel of oil and six packages of liquor for a merchant. The photo was taken during the height of the steamboat era, which ended before the "golden age" of postcards started in 1907.

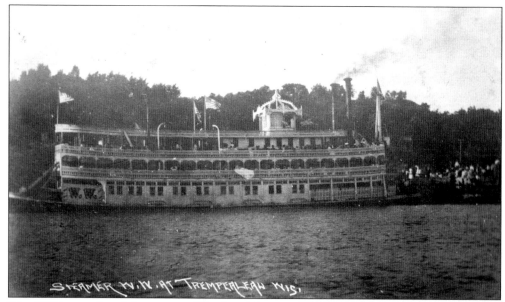

The *W.W.* was a Streckfus steamer. The Streckfus company also operated the *President* and the *J.S.* This photo postcard from *c.* 1910 shows the *W.W.* at the Trempealeau town docks. She was named for Streckfus employee Captain D. Walter Wisherd, who had another steamboat, the *D.W. Wisherd* named after him as well. Because he didn't want liquor on board, people claimed that the initials stood for "Water Wagon."

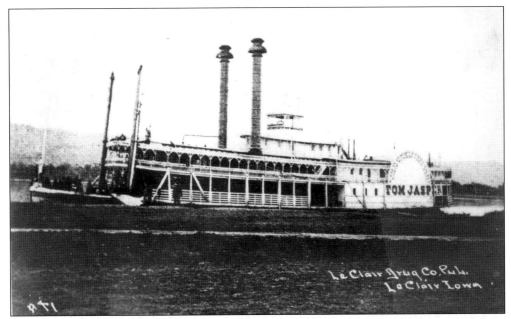

This vintage photograph depicts the steamboat *Tom Jasper* at Winona, which operated from 1867 to 1876, gaining a reputation for being very slow. In 1876 she was re-configured and re-christened *Centennial*. In February 1887, she was wrecked by river ice.

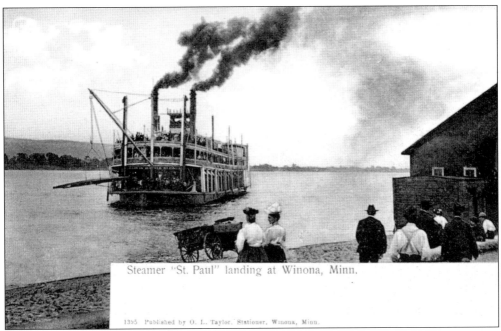

Steamer "St. Paul" landing at Winona, Minn.

1345 Published by O. L. Taylor. Stationer, Winona, Minn.

The *St. Paul* was constructed in St. Louis, Missouri, in 1883. Acquired by the Streckfus Line in 1911, she kept this name until 1940 when she was renamed the *Senator*. She was destroyed in 1953. Written on the back of this card is the message: "June 13th, 1909. Mamie, Ester, Anna, Bertha, and I all went to Winona on the steamer from La Crosse."

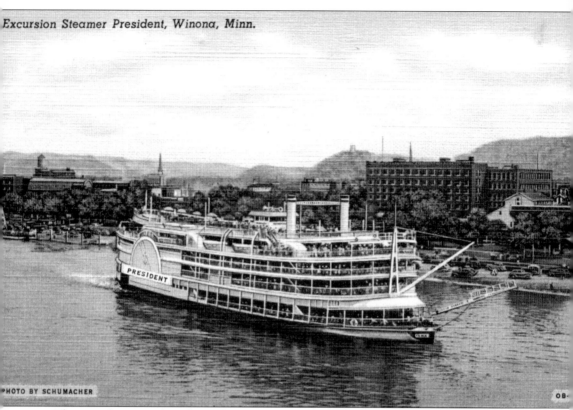

PHOTO BY SCHUMACHER OB-

The steamboat *President*, shown here at Levee Park, started out as the *Cincinnati* in 1924. When renamed the *President* ten years later, she was an excursion boat with room for 3,100, and carried passengers on day outings. At one time, she was the largest excursion boat in America. She is pictured here heading west (upriver) past Winona's waterfront. This boat was most recently used as a casino during the 1990s.

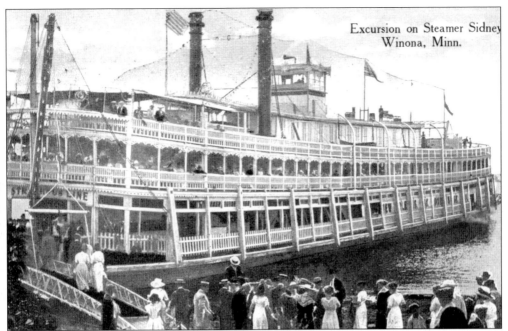

Excursion on Steamer Sidney
Winona, Minn.

Sidney was a steamer in the Streckfus line (which included the *President*, the *St. Paul*, and several others). This postcard was mailed in 1908, and the sender wrote on the back: "This is the boat Ma works on I am going in a week or so." While this postcard mentions Winona, the publisher also published this exact same card saying it was at Lake City.

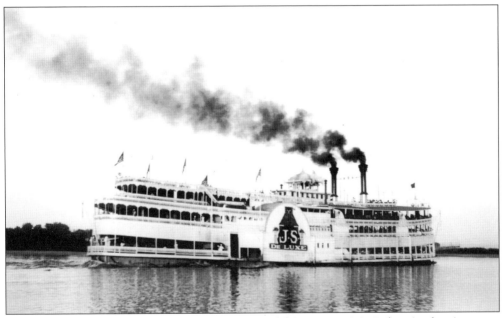

This photograph from the 1930s depicts the Streckfus steamer *J.S. Deluxe* in the river near Trempealeau. She started out as the *Quincy* in 1896, and became the Streckfus flagship *J.S. Deluxe* in 1919. It was later replaced as flagship by *President* in 1934. *J.S. Deluxe* was dismantled in 1939.

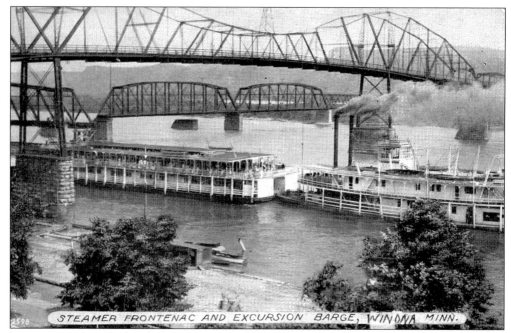

STEAMER FRONTENAC AND EXCURSION BARGE, WINONA MINN.

Frontenac was launched in 1896 at Winona under the ownership of the Laird, Norton Lumber Company. The engine and boilers of the *Juniata* had been added to a hull built the year before in Wabasha. She towed the excursion barge *Mississippi*, and she sank after hitting one of Winona's bridges. Captain Wisherd bought her. The boat's final fate, like that of many steamboats, was destruction by fire. This postcard from 1913 shows the *Frontenac* with an excursion barge.

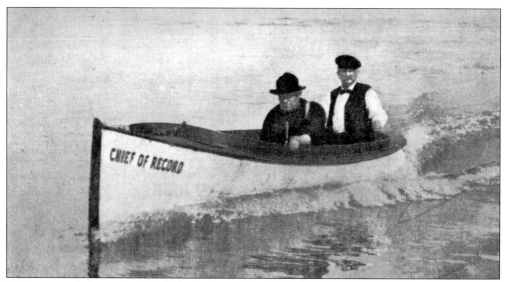

CHIEF OF RECORD

This postcard shows the *Chief of Record* (owned by C. Richmann of Winona), the winner of the race for the fastest boat on the Mississippi, at Wabasha, July 4, 1907.

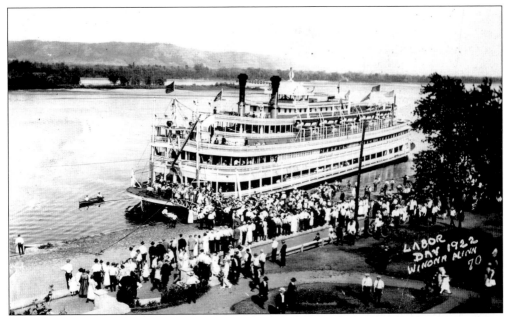

The *Capitol*, one of the Streckfus excursion steamers, is shown in this postcard having pulled up to the docks at Levee Park on Labor Day, 1922. Launched in 1920, this large steamer featured its own jazz band, a dance floor lighted with 2,000 electric lights, and ten lifeboats.

The Winona Steamboat Museum in the *Julius C. Wilkie* came about through the efforts of Dr. Lewis I. Younger and the Winona County Historical Society. The boat, which dated back to 1898, bore the name *James Pearson* when she was brought to Winona and rechristened *Wilkie*. She was drydocked at Levee Park and filled with artifacts of the steamboat era. (Courtesy of the G.R. Brown Postcard Company.)

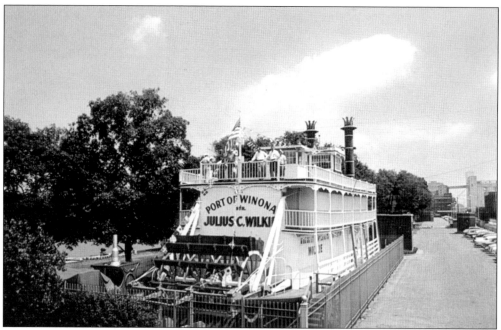

The 18-foot paddle wheel of the *Wilkie* was driven by engines which carried 184 lbs. of steam pressure to deliver 200 horsepower. The engines were twin coal hand-fired boilers. (Courtesy of Verda Goetzman.)

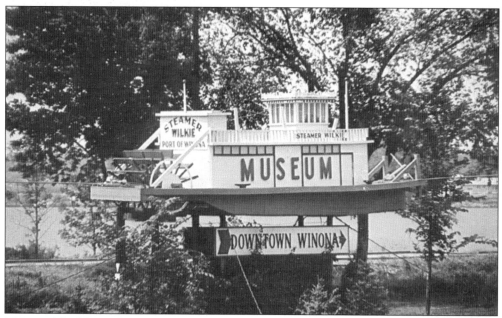

This model of the *Wilkie* is located at the south end of Huff Street where it intersects Highway 61. It is an enduring landmark, inviting travelers to come downtown and visit the steamboat museum even today. (Courtesy of Verda Goetzman.)

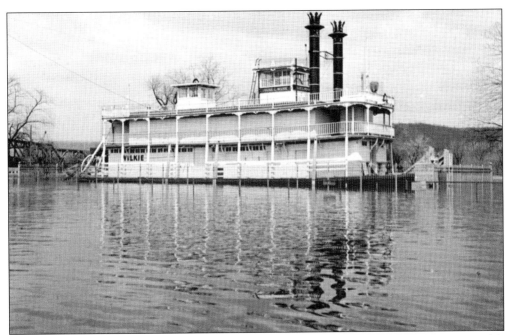

The steamboat *Julius C. Wilkie* sat entirely on dry land in Levee Park. However, as this postcard (photograph by Winona historian L.I. Younger) shows, the great flood of 1965 filled the park and made the boat appear to be riverborne once again.

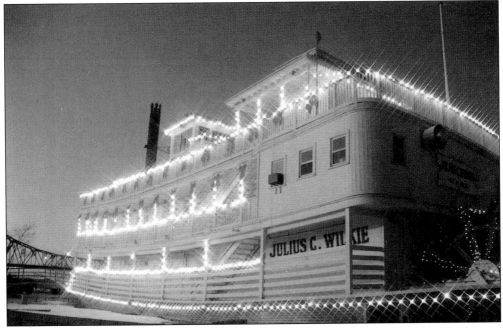

During Levee Park renovations in 1981, the steamboat *Wilkie* was destroyed by fire. Funds were raised and a new Wilkie was built and opened two years later. Like the original, it contains a museum, but this new larger version also features a reception hall. (Courtesy of Kay Shaw.)

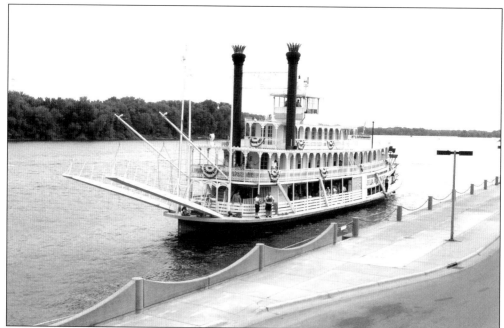

Julia Belle Swain, a replica representative of the great steamboats from earlier times, was built in 1971 as last boat of Dubuque Boat & Boiler Works. She is powered by an engine that dates back to 1915. Currently, she runs short cruises around La Crosse, and from La Crosse to Winona. This photo from 2003 shows her arriving at Levee Park in Winona.

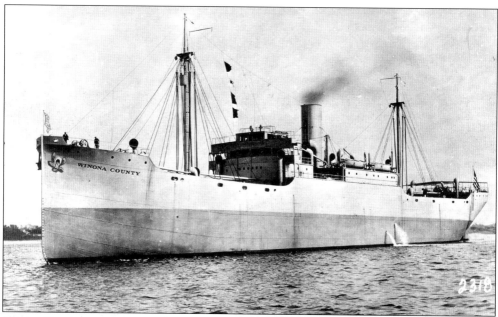

Winona County was an oceangoing ship named for Winona County, Minnesota. She was built in 1919 and first owned by the U.S. Shipping Board, and later owned by the U.S. Maritime Commission. She was leased to Great Britain in 1941 and renamed *Empire Whale*. On March 29, 1943, she was torpedoed and sunk by a German U-boat. Most of the men aboard perished.

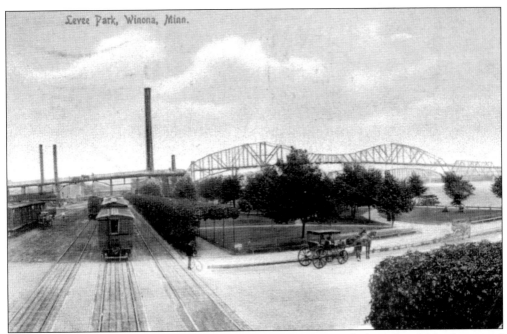

Three modes of transportation can be seen in this 1909 postcard: the railroad, the horse and carriage, and the riverboat (a sternwheel is visible between the trees on the right). There is no hint of the automobile, which would later cause much of the park to be turned into a parking lot.

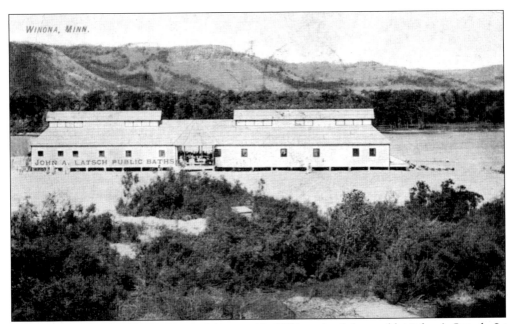

The Latsch Island Bathhouse opened August 19, 1907, on land donated by John A. Latsch. In the first years, the bathhouse faced a beach on the back (Wisconsin) side of the island. This postcard was mailed the year after the bathhouse opened.

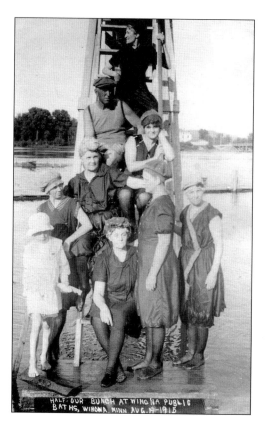

"Half Our Bunch" standing on one of the ladders at the Latsch Island beach, August 19, 1915. For a time, visitors entered the Latsch bathhouse from behind: men on the right, ladies on the left.

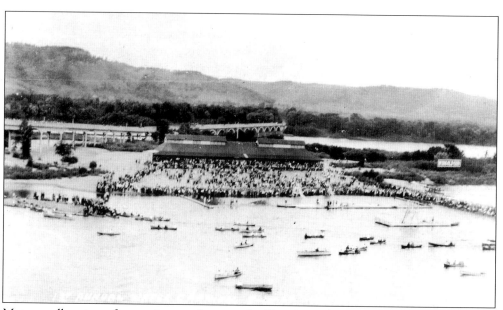

Many small watercraft were in attendance at the First Annual Water Carnival on August 10, 1924. This event on the Latsch is no longer held. Immediately behind the building is the eastern section of the wagon bridge, which will later be re-opened for traffic to Aghaming Park.

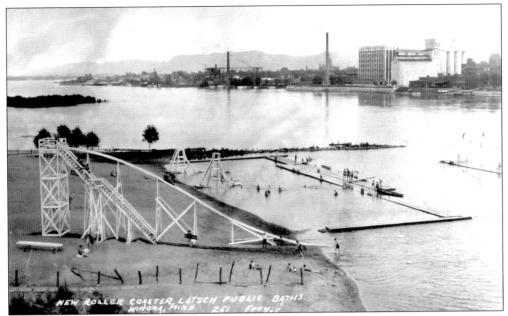

This postcard from the late 1920s shows the new roller coaster at Latsch Beach. In 1974, the beach was closed due to pollution, and the bathhouse was torn down some time afterwards. The city no longer encourages swimming at this beach. For a time the city encouraged swimming at the beach at Lake Park on Lake Winona. Latsch Beach today affords a great view of Winona's skyline and riverfront.

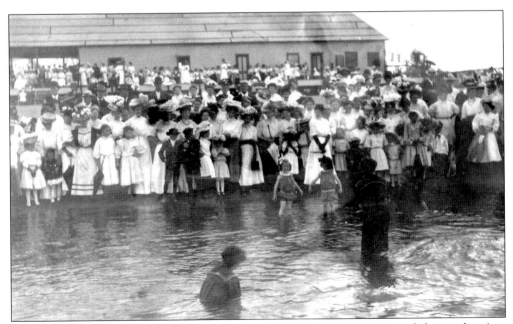

While Latsch Beach was primarily for relaxation and recreation, this postcard shows a baptism ceremony at the beach, with the congregation in their Sunday best.

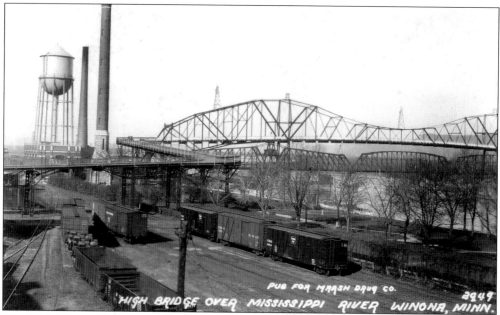

The High Wagon Bridge was completed in 1892 at a cost of $100,000, replacing a cable ferry which had been operating for five years. It started out as a toll bridge. The bridge was replaced in 1942 by the Interstate Bridge.

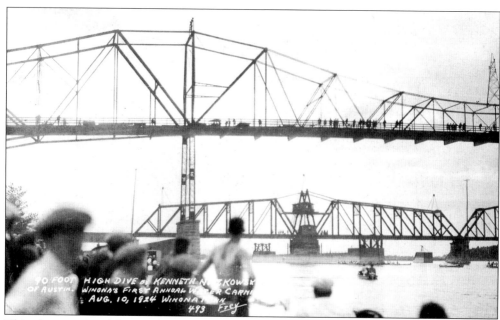

This photo postcard from August 10, 1924 (the date of the first Water Carnival) shows a 90-foot high dive by Kenneth Nitzkowski of Austin, Minnesota. The high wagon bridge, crowded with onlookers, is above, and the railroad swing bridge is below.

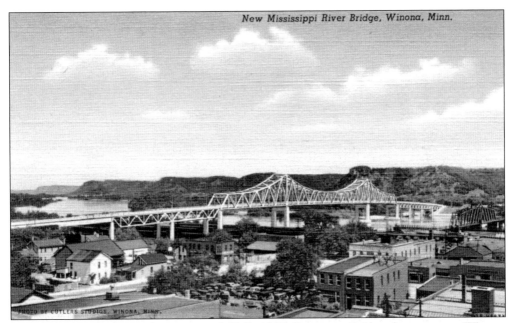

This card depicts the new (constructed 1940–1942) Interstate Bridge that connects Winona with Latsch Island and then Wisconsin. The dark railroad swing bridge can be seen toward the right. The view looks north/northwest over Winona's downtown, and the Wisconsin hills leading toward Fountain City can be seen in the background.

This postcard from 1908 depicts Crooked Slough (to the west of Latsch Island), which is one of the many backwaters in this stretch of the Mississippi River. Mark Twain referred to this area, with its backwaters, channels, lakes, islands, and marshes as the "Thousand Islands." While the construction of nearby dams in 1936 drastically altered the river-scape, Crooked Slough still remains.

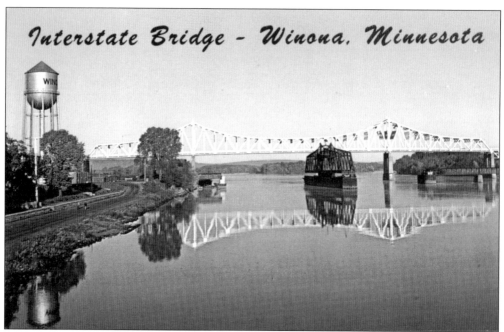

This postcard view is likely from the 1970s, looking up the river to the Interstate Bridge. The railroad swing bridge can be seen on the right. (Courtesy of the G.R. Brown Postcard Company.)

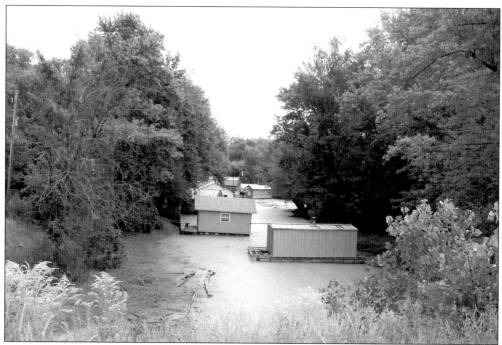

This photograph taken in 2003 shows some of the residential houseboats located on the eastern half of Latsch Island. This community, which includes year-round residents as well as summer residents, is now overseen by the Winona Boathouse Association.

Five

DOWNTOWN

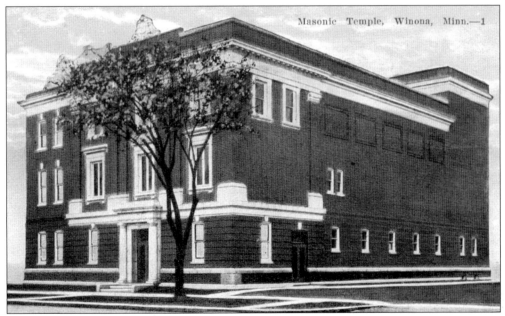

The Winona Masonic Temple, designed by Philadelphia architects Warren Powers Laird and C.F. Osborne, was completed in 1909. In 1979 it was sold to the City of Winona and converted into the Winona Senior Friendship Center. The Masons still use part of the building for their purposes. It is one of many historic buildings in Winona's downtown area.

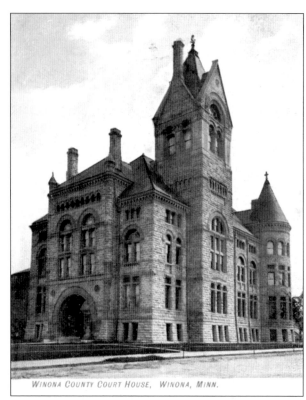

WINONA COUNTY COURT HOUSE, WINONA, MINN.

Winona's first courthouse, designed by prolific area architect C.G. Maybury, was completed in 1862. The second courthouse, shown in this postcard, was designed by C.G. Maybury and his son, Jefferson Maybury. It was completed in 1889. The imposing building was designed in the Richardson Romanesque style.

This postcard from 1975 shows the courthouse rooftop with the bluffs in the background. In 2000, a ceiling collapse on the fourth floor resulted in damaged water pipes which flooded the building from the top down, causing extensive damage. After extensive and expensive renovations and repairs, it was fully re-occupied in 2003. (Courtesy of Dick Swift.)

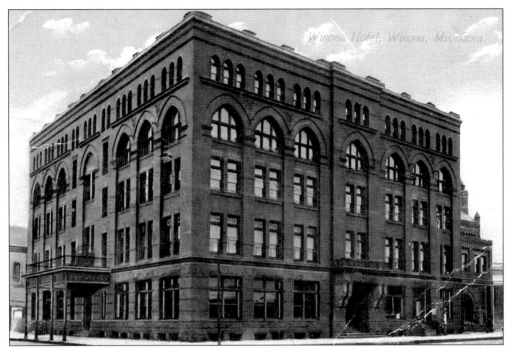

The Winona Hotel at 151 Johnson Street was opened in 1890 on the site of an earlier hotel called the Huff House, which had opened in 1855. The Winona Hotel has been renovated and turned into the Kensington Apartments. It is now on the National Register of Historic Places.

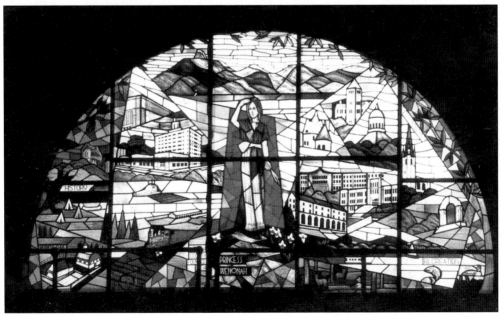

The stained glass window seen in this recent postcard is found in the Winona County Historical Museum. It was designed by Edward A. Glubka of the Conway stained glass studio, one of several stained glass studios that have been located in Winona over the years. It depicts scenes from different points in Winona history. (Courtesy of Jim Galewski.)

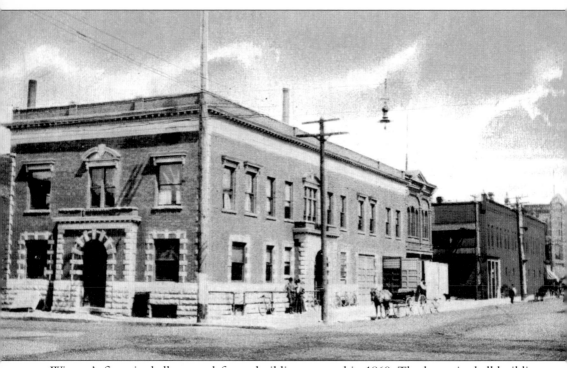

Winona's first city hall, a wood-frame building, opened in 1860. The later city hall building, shown in this postcard, was built in 1906 and replaced by the current city hall in 1939. This is one of many postcards printed with the following paragraph on the back: "Winona—Population 25,000. The Gate City of the state is in the south east corner of Minnesota on the Mississippi River has five railroads and three steamboat lines. Is 286 miles north-west of Chicago. 100 miles south of the Twin Cities. Winona is noted for Beaut. Scenery, Pretty Drives, Fine Residences, Large Manufacturing and Jobbing Interests." This building still stands on Fourth Street across from the current City Hall.

This advertising card for Morgan's Book Stall at 68 W. Third Street in downtown Winona has two paragraphs describing the proper care of books on the back. This bookstore is long gone.

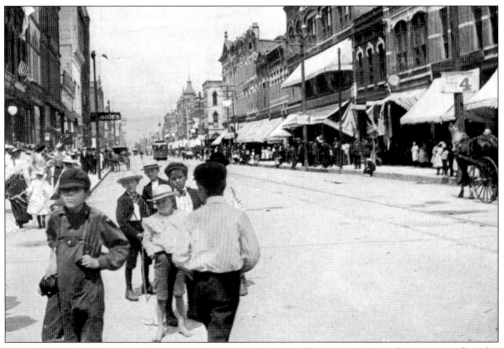

This postcard, probably from around 1910, shows Third Street. A boy mugs for the photographer, and a streetcar is in the far background.

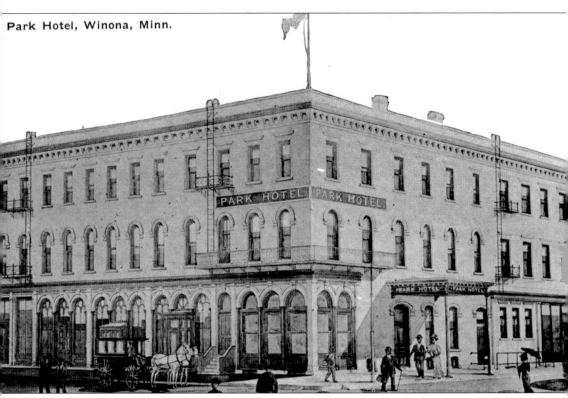

This artist's drawing depicts the Park Hotel, which was located on the southeast corner of Johnson and Second Streets. This message is written on the back: "This is the hotel we are stopping at overnight. Ruth had the adenoids removed this morning." Perhaps Ruth was on the way home from the Mayo Clinic in Rochester. This hotel was within walking distance of the Northwestern depot, and was a favorite place for businessmen to stay.

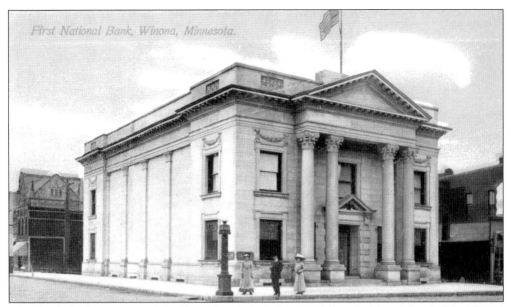

This bank building was originally to be designed by Prairie School architects Purcell and Elmslie (who also designed Merchants Bank). Their striking design was rejected, and this much more conventional bank building designed by other architects was completed in 1908, only to be demolished in the 1960s. This postcard is one of many published by the Jones and Kroeger Company.

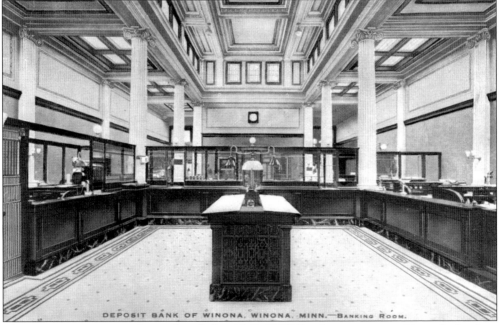

The Winona Deposit Bank was founded in 1868. H.W. Lamberton was president. At the time this postcard was printed, sometime in the first part of the 20th century, the bank had a $950,000 guarantee fund, and it occupied the first modern bank building in Winona. It was located at 50 W. Third Street.

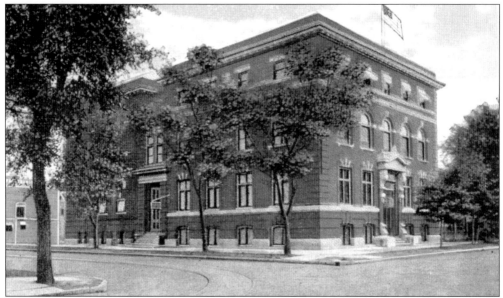

According to the 1910 Winona City Directory, the rooms and activities at the "Y" included a public reading and corresponding room, parlors, game rooms, gymnasium, shower and tub baths, swimming pool, bowling alleys, educational classes, boarding house register, religious meetings, and Bible classes for men. Located at the corner of Fifth and Johnson, this building burned down in 1946, and was replaced by the current YMCA building on Winona Street. A Hardee's restaurant is at the site of the old building.

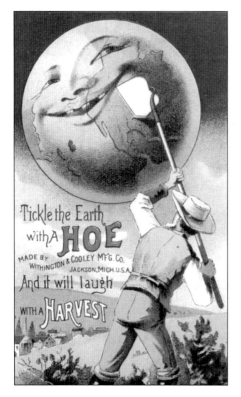

This card advertised a hoe made by a company in Jackson, Michigan, and sold by the R.D. Cone Company (with Cone information printed on the back). Royal D. Cone started his "Everything Place" in 1855, selling dry goods and equipment, such as this hoe, to the settlers. The company survived a destructive fire in 1862 and the death of Mr. Cone in 1898. It continues to this day as the R.D. Cone Antique Mall on East Second Street.

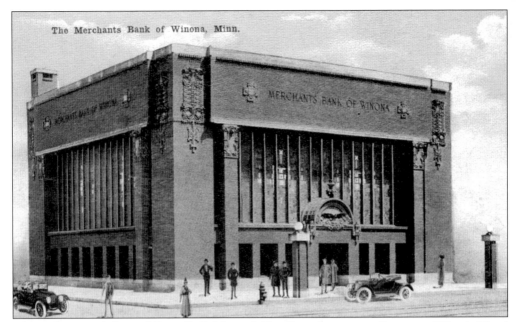

The architectural firm of Purcell, Feick, and Elmslie, who were colleagues of Frank Lloyd Wright, designed several banks in the Midwest (including another in Winona, which was never built). Merchants Bank, completed in 1912 in Winona, was their most elaborate. The building has undergone expansion, remodeling, and restoration since this 1920 postcard was printed, but retains much of its ornate glory.

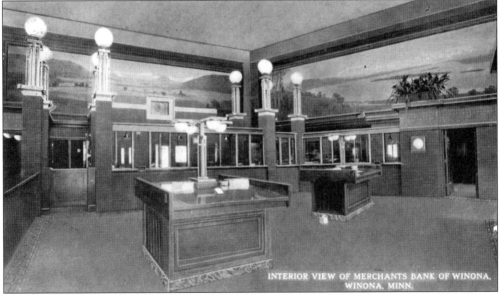

The ornate interior of Merchants Bank features murals of local farm scenes and vertical light standards with round globes, both of which are seen in this vintage postcard. Much of the remarkable interior and exterior of the bank have been preserved, and restored and this successful financial institution now has branches as far south as La Crescent and as far north as the Twin Cities.

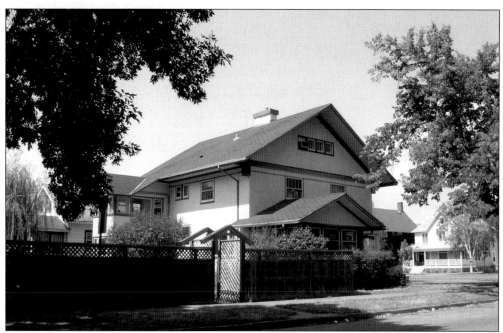

This private residence on West Broadway was designed for Dr. Sidney L. Gallagher (a dentist) by the same architects who designed Merchants Bank. It was completed in 1913 and is a typical Prairie School residence, with wide eaves and the characteristic window placement. This is a photograph from 2003.

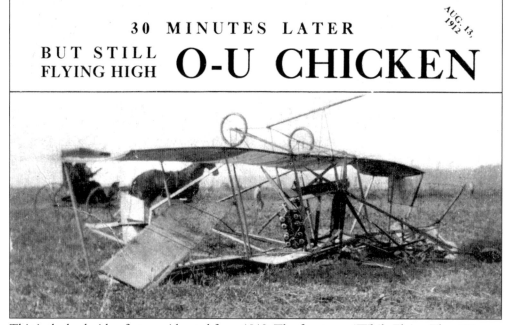

This is the back side of a two-side card from 1912. The front says "While Flying Thru Winona Drop Off at Chicken Gus' O-U Chicken" (at 118 West Third Street). The plane, shown upside down and crashed in this view, is right-side up on the front side of the card.

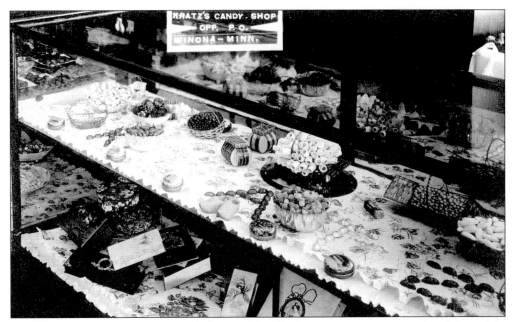

The Kratz candy store at 164 Main Street, next door to Hayner's Jewelry, was the place in Winona to get fine candy. The confectionary created much of the candy sold, including spin candy and caramel chocolates. The store closed in the early 1950s. This postcard displays just some of the store's wares.

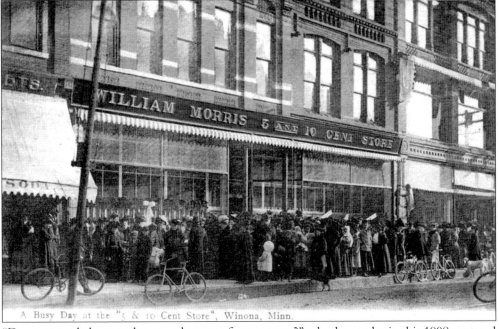

A Busy Day at the "5 & 10 Cent Store", Winona, Minn.

"Do you people have such a crowd at any of your stores?" asks the sender in this 1908 postcard mailed to someone in Dodge City, Minnesota. The building which at one time housed the William Morris 5 and 10 Cent Store was lost in urban renewal in recent decades.

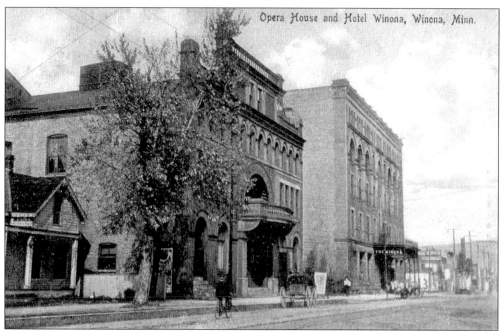

The Winona Opera House hosted great entertainment acts that stopped off on the route between Chicago and the Twin Cities. Much of the ornateness of the exterior was lost when it was remodeled into the Winona Theatre (a movie house). It was demolished in the early 1990s and is now a parking lot.

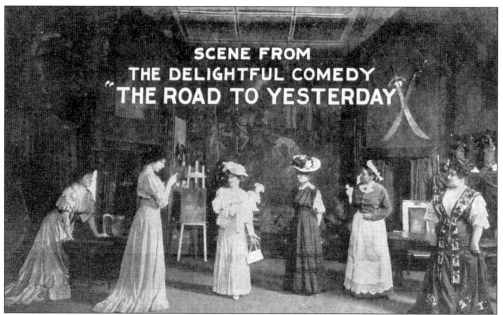

SCENE FROM
THE DELIGHTFUL COMEDY
"THE ROAD TO YESTERDAY"

This postcard advertises *The Road to Yesterday*, a play starring Minnie DuPree, coming to Winona right after a successful run at the Lyric Theatre in New York. The postcard was mailed by O.F. Burlingame, the Winona Opera House manager, the day before the October 30, 1908 play was to run.

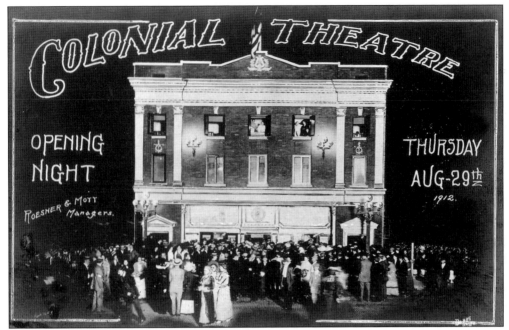

This postcard commemorates the grand opening of the Colonial Theatre in 1912. Later, it was Smith's Furniture. The building still stands on the east side of Main, between Third and Fourth streets, as an office building.

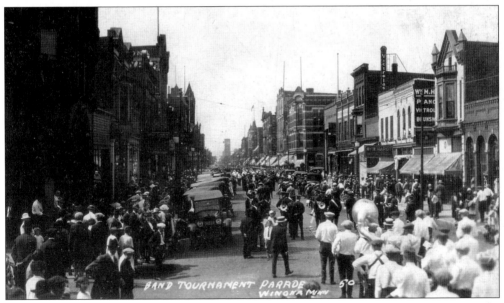

This postcard from the 1920s shows marching bands going west down Third Street in the Band Tournament Parade. Note how the sides of the street are crowded with cars, which usually are not left on the streets for parades today.

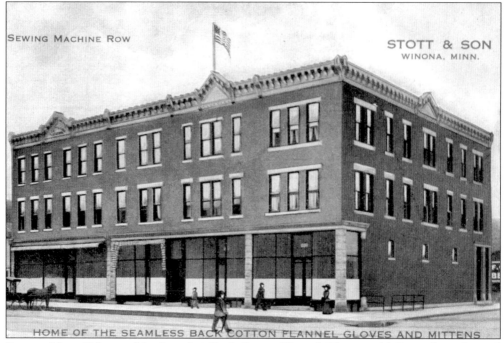

Stott and Son, "Home of the Seamless Back Cotton Flannel Gloves and Mittens," was located on East Third Street. It later became a furniture store.

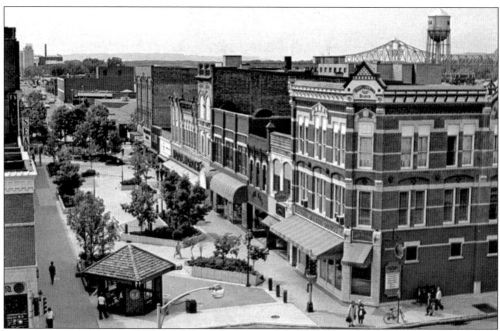

This postcard shows the plaza section of Third Street *c.* 1975. The plaza has since been removed (1993). The Odd Fellows building on the right was occupied by a pharmacy (Ted Maier Drug at the time of this photo) for decades. It is now an orthodontist's office, with apartments on the upper floors. (Courtesy of Dick Swift.)

Six

CHURCHES

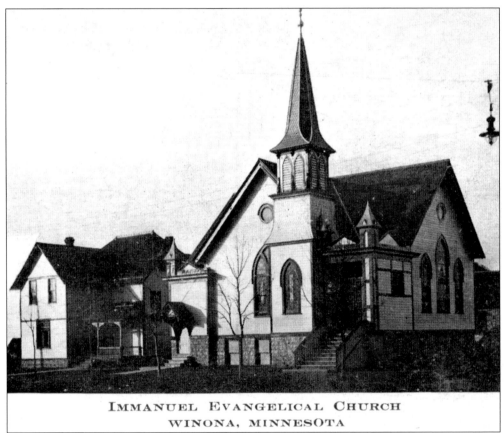

IMMANUEL EVANGELICAL CHURCH
WINONA, MINNESOTA

This postcard from before 1910 shows Immanuel Evangelical Church on the corner of King and South Baker streets. During the time leading up to the year 1900, many of Winona's wooden churches were replaced by imposing stone and masonry edifices as congregations outgrew smaller buildings and early wooden churches burned down.

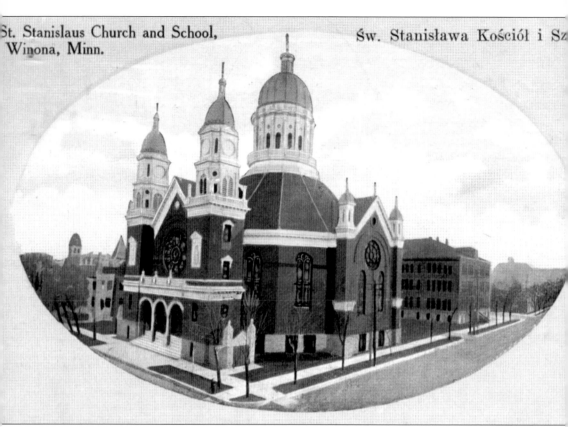

St. Stanislaus Kostka Parish was organized in 1871 by 100 Polish immigrant families who were not being served by the existing Roman Catholic services held in English or German. Their first church building was dedicated in 1872. When the congregation outgrew this building, the current church building was built in 1894 at a cost of $86,000. This building was designed in the Romanesque style by prolific Winona architect Charles G. Maybury.

As the congregation and mission of "St. Stan's" expanded, a 12-room rectory was added in 1898, and a school with 17 classrooms was added in 1905. It was the same year that St. Casimir's parish was split off to serve Polish immigrant families on Winona's west side.

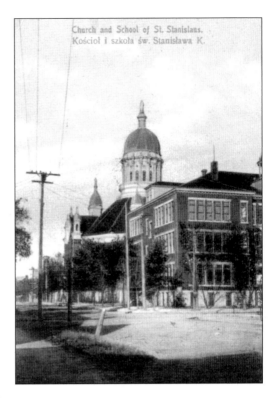

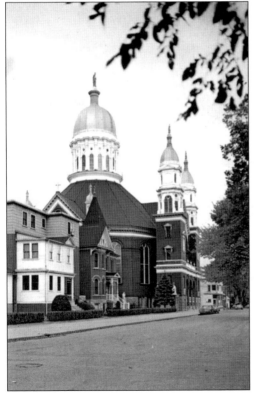

In this postcard from the 1960s, St. Stan's convent can be seen as the second building from the left, next to the church. The church itself survived a 1966 fire which did not cause major structural damage. (Oliver Durfey Collection, Courtesy of the Winona County Historical Society.)

The current St. Stan's School was built in 1965–1966. Currently, it is called St. Stan's Middle School, and serves grades four through six and has an enrollment of 177 students. This postcard view is likely from the early 1960s. (Oliver Durfey Collection, Courtesy of the Winona County Historical Society.)

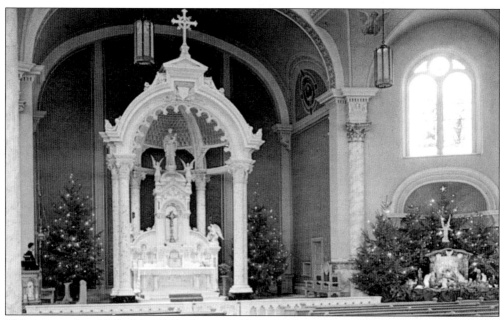

This postcard published in 1961 shows a Christmastime view of the main altar inside St. Stan's. (Oliver Durfey Collection, Courtesy of the Winona County Historical Society.)

First Congregational Church, first organized in 1854, is the oldest congregation in southern Minnesota. After meeting in several different locations and two church buildings (one at Second and Franklin, and another at Fourth and Lafayette), the church's current home on the corner of West Broadway was dedicated in 1882.

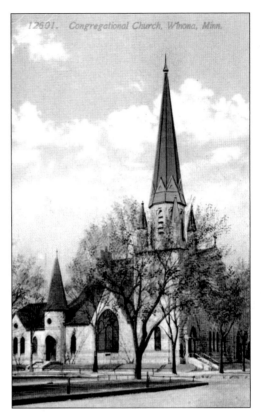

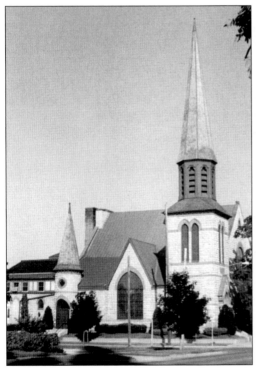

This recent postcard, published in memory of John C. Pendleton (husband of author Mary Pendleton), depicts First Congregational Church as it appears today, 150 years after Reverend Hiram Hamilton first led the congregation. The congregation is part of the United Church of Christ, and has had a radio ministry since 1957.

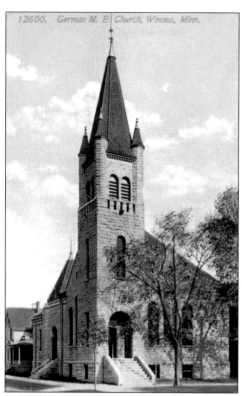

The German Methodist Episcopal Church was organized in 1858, first led by the Reverend John Westerfield. The building shown in this postcard (the second occupied by the congregation) was located at the corner of Main and Sanborn. In 1923, the congregation united with the Central Methodist congregation. Afterwards, this building was used by the Christian Science church.

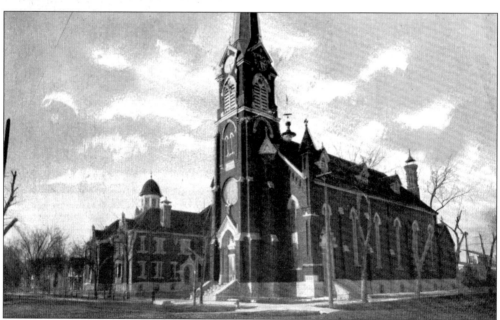

The Church of St. Joseph was located on the corner of East Fifth and Walnut streets. This Roman Catholic congregation merged with St. Thomas in 1953. In 1910, at the time this postcard was mailed, the pastor was Joseph Meier, and Bishop Heffron was an officer. This card was mailed to Esther Gage, who had been baptized in this church.

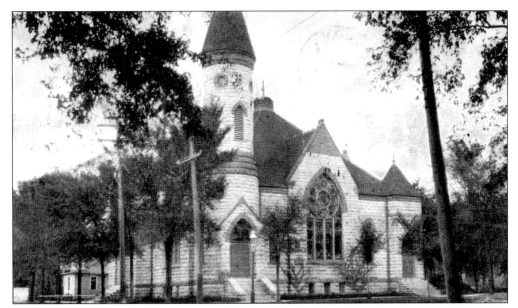

First Baptist Church was organized in 1854. The first church building survived the great Winona fire of 1862, and because of this the congregation was able to help other Winonans after the disaster. However, this wood-frame building succumbed to fire in 1887. The current building at 366 West Broadway, constructed with native magnesium limestone and sandstone trim, was under construction from 1888 to 1893.

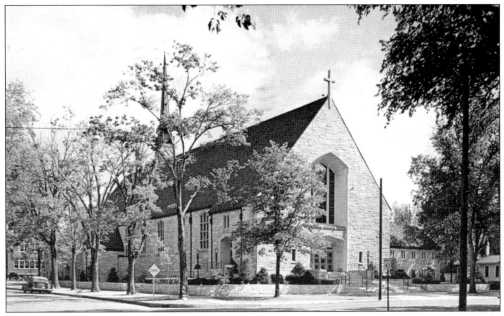

The Cathedral of the Sacred Heart, a Roman Catholic parish in the Diocese of Winona, was inaugurated in 1952 and dedicated in 1953 to serve as the Pro-Cathedral for the Diocese of Winona. Before this, the churches of St. Thomas and St. Joseph served as the Pro-Cathedral. The Cathedral of the Sacred Heart was constructed of a type of limestone known as Winona Travertine. It is an example of a beautiful stone church built in Winona in the modern era.

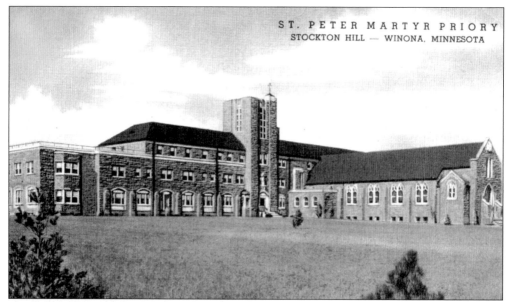

This linen postcard depicts the St. Peter Martyr Priory, which was founded as a Dominican institution. It is located about one mile beyond St. Mary's College on Stockton Hill. The priory was closed in the 1960s, and was purchased by the Lefebrites (another group of Roman Catholics) in the early 1990s to be used as a seminary. The cemetery on the grounds is still owned by the Dominicans.

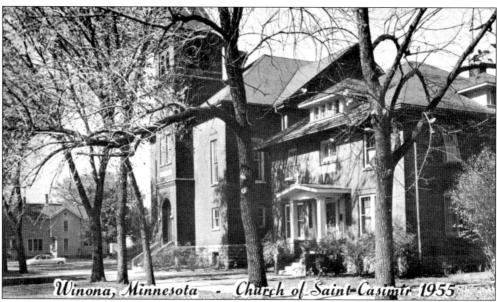

Winona, Minnesota - Church of Saint Casimir 1955

St. Casimir's Parish was founded in 1881 by Polish settlers. These buildings are located on the north side of West Broadway between Ewing and Sioux. The back of this 1955 postcard lists the rectory in left background, the proposed new church building site (now a parking lot) at left, church and school building at center, and Sisters' convent at right.

Free Will Baptist Church, depicted in this 1899 view on a photo postcard, was located on the corner of Lincoln and Howard Streets. In 1910 (about the time this postcard was published), the pastor was Rev. Curtis Marston and there were two services on Sunday (10:30 a.m. and 7:30 p.m.).

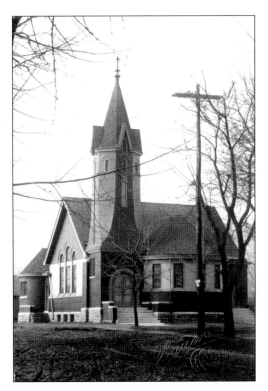

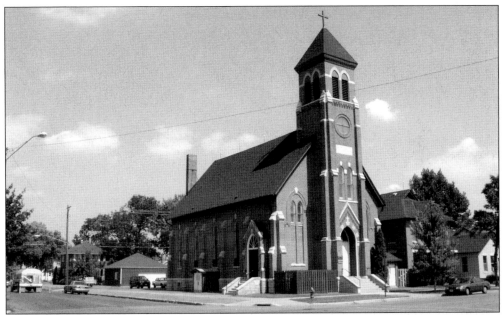

The construction of this church, dedicated to St. John Nepomucene, was started in 1883 with the purchase of land for $600 to build a church to serve Winona's Bohemian community. During a long period in which a new fund-raising campaign was started, the congregation members had to do a lot of the construction themselves. The building was completed in 1887. It is located at 558 East Broadway, very close to St. Stan's.

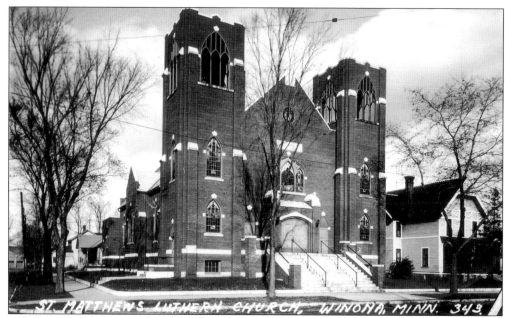

St. Matthew's Lutheran Church at 766 West Wabasha Street was founded in 1920 by 165 families to serve the population in the part of Winona west of Huff Street. For a while, they met in a house which later became the church parsonage. The current Gothic style building with its twin steeples was built during the last half of 1925, for a cost of $50,000, including furnishings.

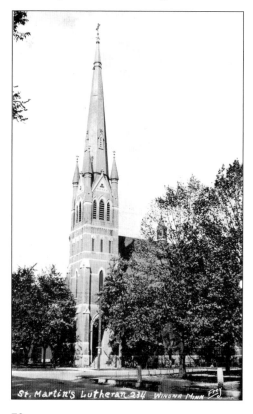

This church was organized in the spring of 1856 as St. Martin's German Lutheran Church.

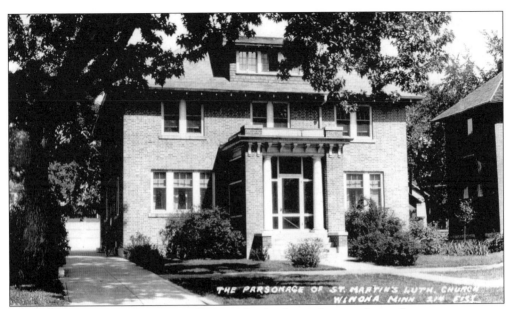

The parsonage of St. Martin's is still in use, having housed generations of pastors.

Central Methodist Church was first founded in 1855 with five members, under the name of the First Methodist Episcopal Church. The building seen in this 1909 postcard was dedicated in 1897, replacing a previous church building that had been destroyed by fire. In January of 1961, this building was severely damaged by fire, except for the steeple, bells, and guildhall.

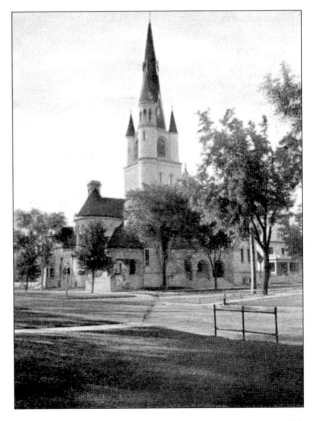

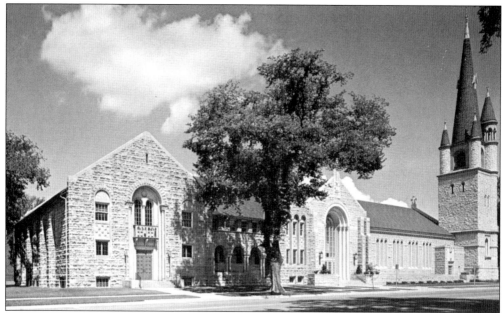

Looking northeast from the front of First Congregational Church, this modern-era chrome postcard shows Central Methodist Church. After the 1961 fire, the cornerstone for the reconstructed building was laid December 8, 1963, and the church was consecrated a year later. It now covers the southern half of one city block along Broadway between Main and Johnson. (Courtesy of Alf Photography.)

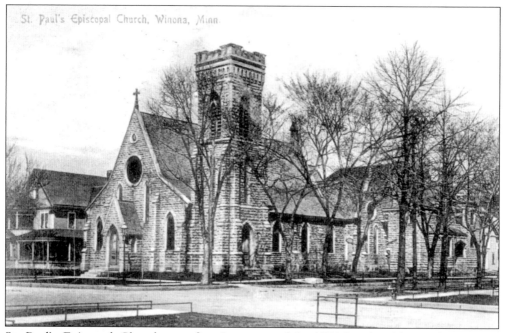

St. Paul's Episcopal Church was first incorporated in 1856 by the Olmstead, Sargeant, Norton, Curtis, and Bingham families. It was the sixth church founded in Winona. Construction on the present building began in 1873.

Seven

COLLEGES AND SCHOOLS

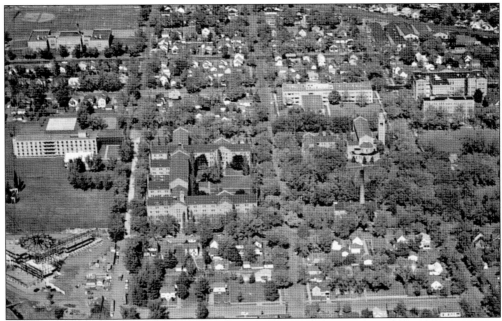

This aerial photo from 1963 shows most of Winona's educational institutions. Jefferson Elementary (a public school) is on the upper left, and the home of Cotter High School (since 1992) is in the upper right. Tau Center, now part of Winona State University, is shown partially built in the lower left, and the buildings in the center belonged to the College of St. Teresa. St. Anne's Hospice is in the center of the left edge. (Courtesy of the G.R. Brown Postcard Company.)

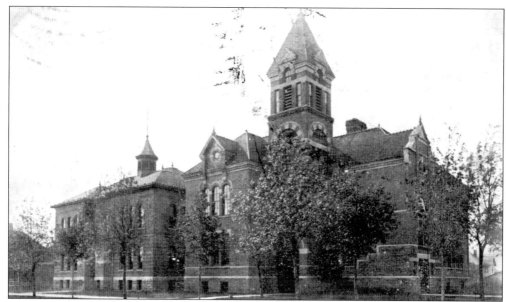

Jefferson School was built in 1887 in the Victorian style. It was located at Fifth and Cummings streets. It was replaced by the current flat-roofed building in 1939. The playground behind the current school is where this old building used to stand.

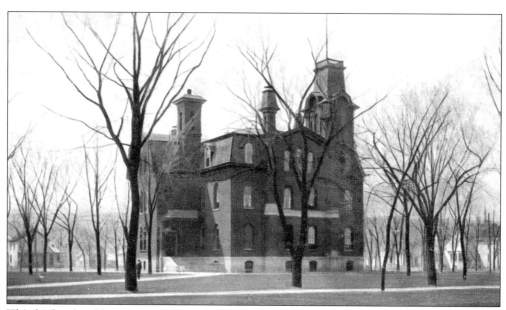

This high school building was built in 1867. That year, the Winona County school district schoolhouses numbered 71 frame buildings, 14 log structures, and 1 brick building. This high school building was replaced by the one on Broadway between Winona and Washington Streets which opened in 1888. The 1867 building became Central Grade School, which itself was replaced during the 1930s.

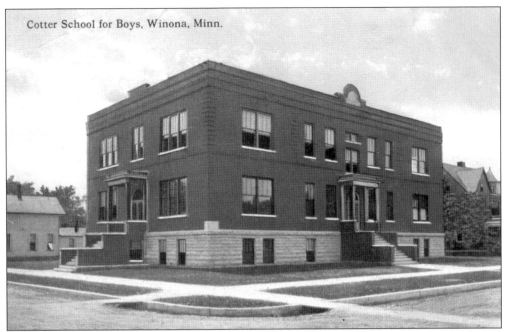

Cotter School for Boys, Winona, Minn.

This school started as Cotter School for Boys in 1911. It was named for Joseph B. Cotter, the founding bishop of the Diocese of Winona. Cotter High School has left the building shown on this postcard and is now located on West Broadway in a former College of St. Teresa building. It now serves 360 students in grades 9 through 12.

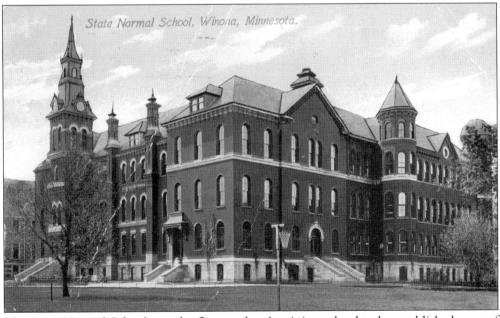

State Normal School, Winona, Minnesota.

The State Normal School was the first teachers' training school to be established west of the Mississippi River. It was chartered in 1858 and classes commenced in 1860. The first building constructed specifically for the school (in 1866) is shown in this postcard. It burned down in 1922.

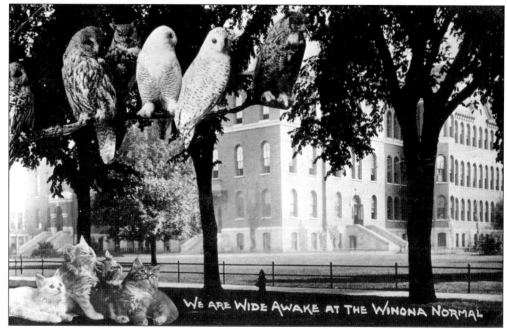

This postcard of birds and cats in front of the Normal School was mailed to someone named Birdie Sullivan in 1910.

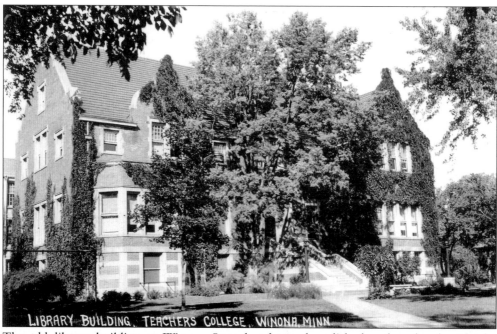

The old library building at Winona State has been demolished and replaced with the university's athletic building. It also contained a gymnasium and kindergarten.

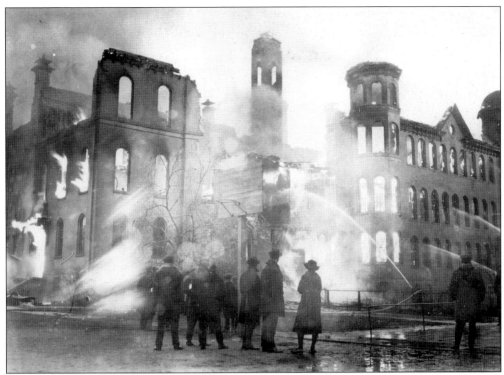

In 1921, the State Normal School became Winona State Teachers' College, and began offering bachelor's degrees. The main building burned on December 3, 1922. These two photographs show the building during and immediately after the fire.

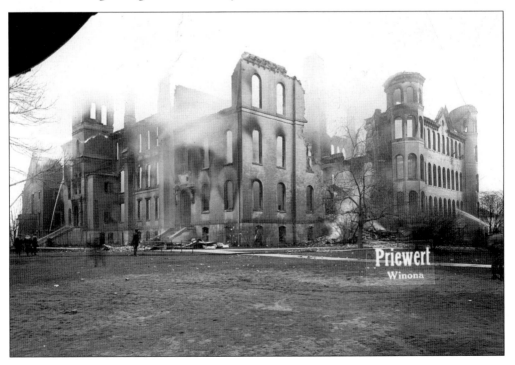

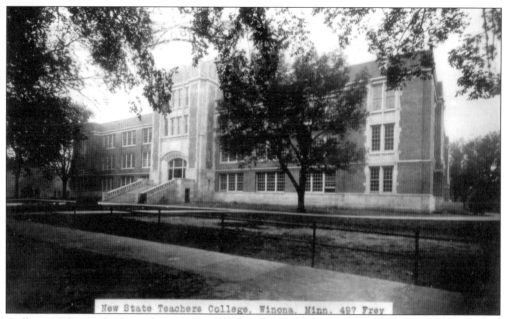

New State Teachers College, Winona, Minn. 497 Frey

College Hall was built as the main building of Winona State Teachers' College after a fire destroyed the main building. It was later renamed Somsen Hall, and has since seen much remodeling, renovation, and expansion. This postcard shows the building in 1947.

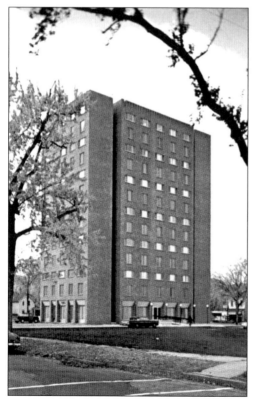

Sheehan Hall, at 14 stories, is one of Winona's few skyscrapers. When it was first built in 1967 at Winona State College, it held 392 students. It is currently a female residence hall, among seven residence halls at Winona State University.

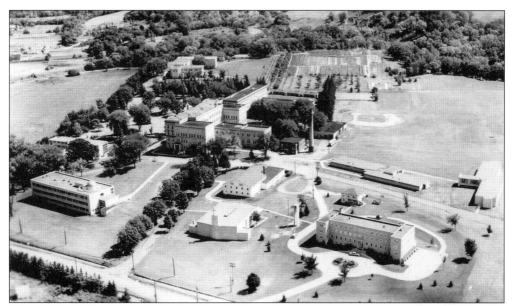

Bishop Patrick Heffron almost single-handedly raised the funds to start St. Mary's College. In 1933, the Christian Brothers (an international Catholic teaching order) took charge of the administration and staffing of the college. Located just southwest of Winona, it is now called St. Mary's University of Minnesota.

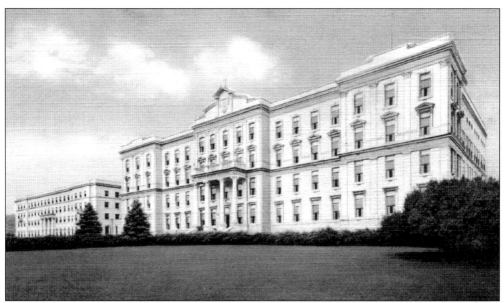

Built in 1912 and modeled after buildings in the Vatican, St. Mary's Hall at St. Mary's University for a time contained the entire college. It contained dormitory space, classrooms, laboratories, and offices. The building still employs these mixed uses, but now there are several other specialized buildings on the campus.

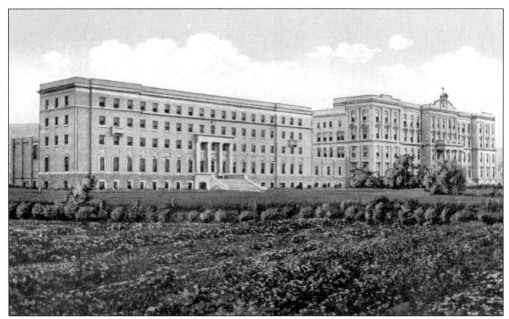

Heffron Hall (left) at St. Mary's University was named after Bishop Heffron, who was shot by Father Lesches in 1915. Shortly after Lesches' death in 1943, claims of hauntings by Lesches' ghost in Heffron Hall began. These were seriously investigated by photographers and researchers in 1969.

This chrome postcard shows the Immaculate Heart of Mary Seminary. Built in 1948 at the order of Bishop Leo Binz, it is located on the campus of St. Mary's University. Many of the active priests in the Diocese of Winona have been trained in this building. It is now operated by the Diocese as a "university-level priestly formation program." Examples of the many classes taught here include Logic, Metaphysics, and the Mystery of Salvation.

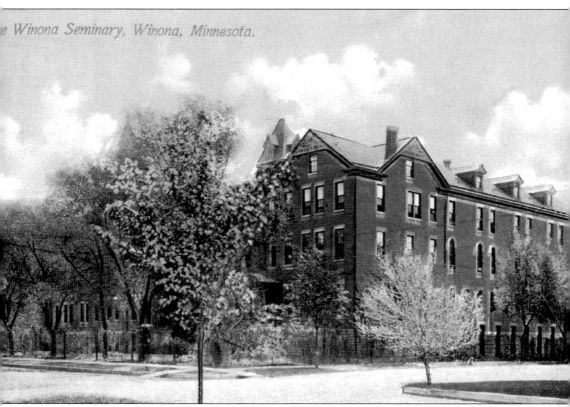

The largest building in Winona at the time, St. Mary's Academy Hall was built in 1885. It was also known as the Winona Seminary. This was the first building in the college that was later renamed the College of St. Teresa in 1912 (the date this postcard was mailed). Bishop Cotter sold St. Mary's Academy Hall to the Sisters of St. Francis in Rochester, who took possession of it in 1894. This building later became St. Mary's Science Hall, and was demolished in 1960 when the new science building (the Roger Bacon building on West Broadway) was completed.

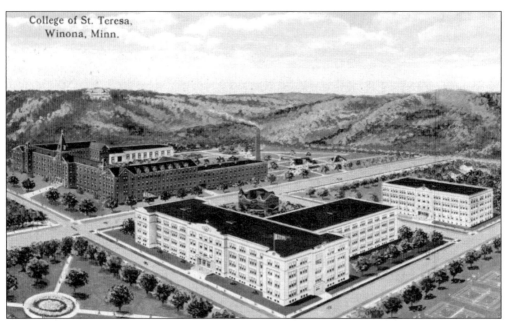

This postcard was mailed out as an advertisement by the college secretary in 1916. It shows the large buildings of the time: St. Mary's Hall, St. Teresa Hall, and St. Cecilia Hall.

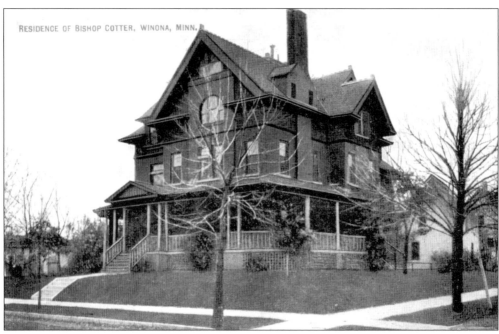

Joseph B. Cotter was the first bishop of the Diocese of Winona. He was born in Liverpool, England, on November 19, 1844. The brick Queen Anne style home shown here was designed by J.N. Maybury (son of C.G. Maybury) and constructed in 1890. After the bishop's death, his house became part of the College of St. Teresa as Assisi Hall, and later Cotter Hall. It was torn down in 1991.

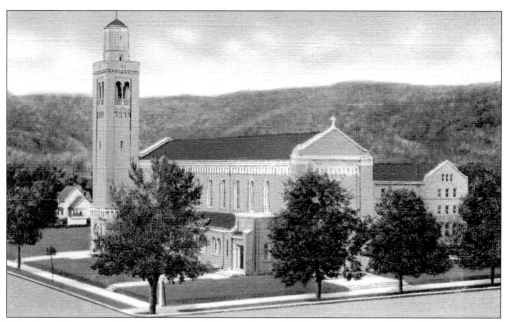

The chapel seen on this linen postcard from the mid-20th century was the religious center of the College of St. Teresa. Completed in 1924, this building still remains a religious center and is used by the Cotter High School.

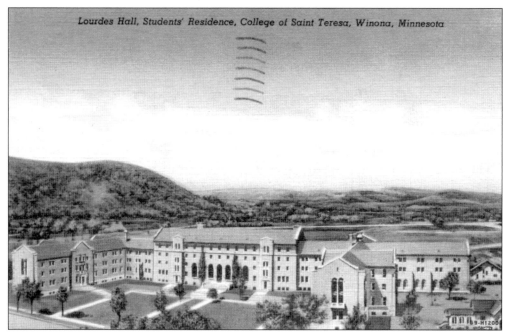

Lourdes Hall, Students' Residence, College of Saint Teresa, Winona, Minnesota

Completed in 1928, Lourdes Hall was the main living space at the College of St. Teresa. It was built containing dorm and dining space and a swimming pool. It is now a Winona State University dormitory, one of a few former St. Teresa buildings that are now part of Winona State.

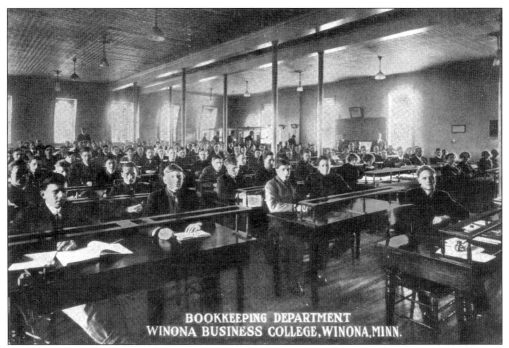

This postcard from 1915 advertises: "Booking, stenography, and stenotype, all courses that lead to a good position and good pay, are taught at this institution." Winona Business College was located at 101 E. Second Street.

Before the building in this 1955 postcard was a religious retreat, it was a nightclub, and it also contained a swimming pool open to the public. Afterward, it was Riverhaven (a parent co-op school), and it later came under state ownership. The building was torn down and the land added to a state park. (Courtesy of Dick Swift. The postcards by Dick Swift in this book were part of a fundraiser for Riverhaven School.)

Eight
WATKINS, KING, AND MAHER

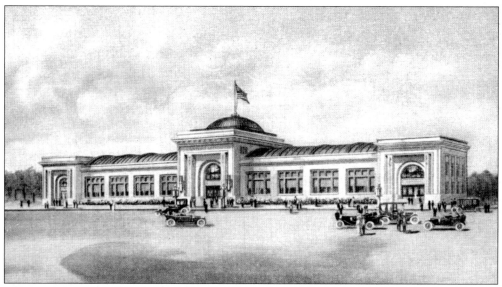

This artists-view postcard of the Watkins administration building is a very common antique Winona postcard. Built during 1911 and 1912, this ornate and beautiful building was designed by George W. Maher of Chicago. Maher designed other buildings in and around Winona for the Watkins company and related persons.

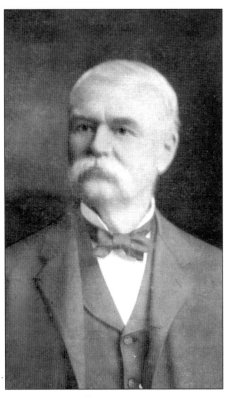

This postcard depicting Watkins Products founder J.R. Watkins was used by the company as a sales tool. "Hello Good People. I'll call upon you soon with a full line of the Watkins goods. Please have a nice order ready for me. It's a pleasure to furnish these wonderful goods to our customers. The Watkins Man." Joseph Ray Watkins started the Watkins company in Plainview, Minnesota, in 1868 and moved it to Winona in 1885, where it thrives to this day.

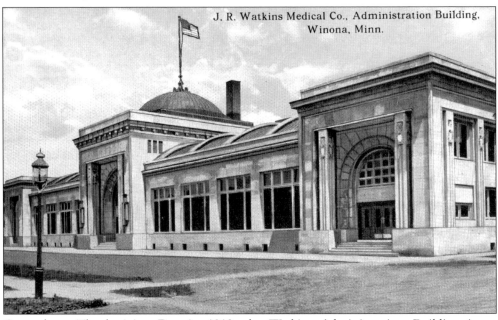

Opened on Thanksgiving Day in 1912, the Watkins Administration Building is an architectural gem which was constructed with a variety of fine materials and includes Tiffany windows. The architect, George Washington Maher (1864–1926), was a colleague of Frank Lloyd Wright, and like Wright, designed in the Prairie style.

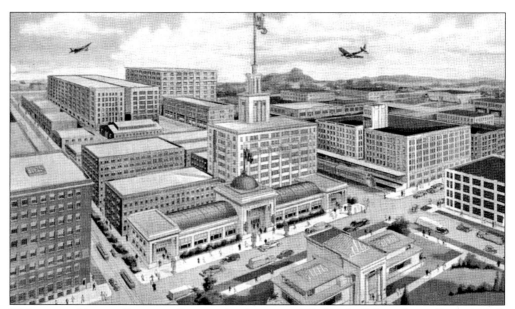

This postcard is actually a sort of composite that moves Watkins buildings from all over North America (including the Winona Savings Bank located blocks away in Winona) to positions across the street from the actual Watkins building complex in eastern Winona.

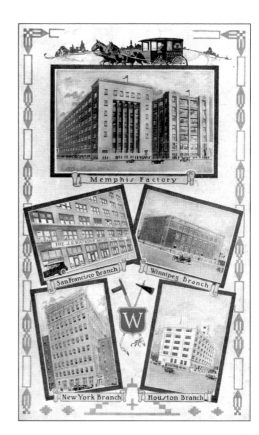

This page from the vintage Watkins booklet, *Wenonah: The Story of an Indian Maid*, shows some of the Watkins buildings outside of the Winona area. The Memphis building was designed by George W. Maher.

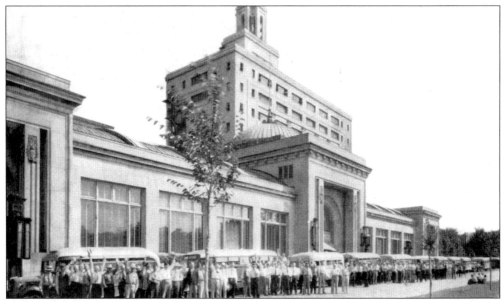

This postcard, mailed in 1940, shows some of the busloads of visitors which resulted in 1,319 visiting Watkins in a single day. In addition to the offices, the card mentions Watkins Experimental Farm, which hosted field trips for school children.

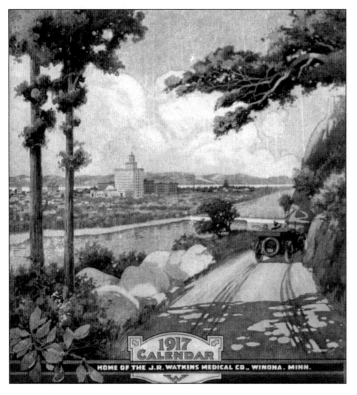

For many years, the Watkins company published yearly almanacs containing weather information, recipes, astrological charts, home medicine, and more. The painting on the back cover of the 1917 almanac shows a car driving east on the road south of Lake Winona, with the outsized Watkins buildings looming in the distance, and Sugar Loaf below the branch in the upper-right corner.

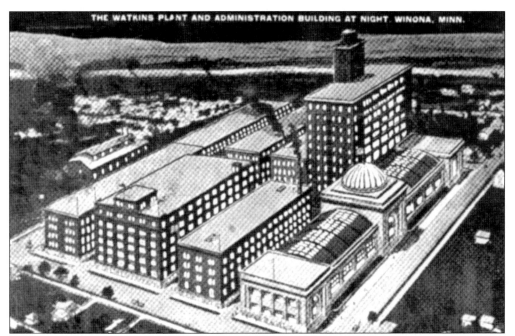

The Watkins buildings were built between 1889 and 1914. The domed structure is the administration building. The four-story building to the left of the administration building (bottom edge) is the museum and store. The tower is used for manufacturing, and the rest of the buildings are used for inventory, bottling, and receiving.

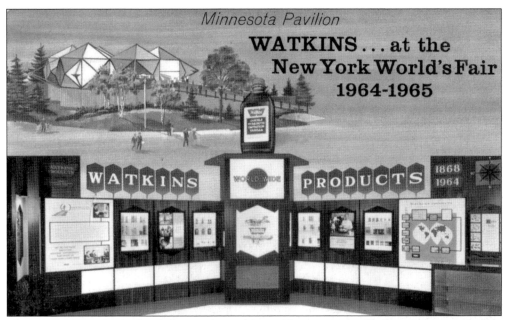

The caption on the back of this card proclaims: "A panoramic display of the progressive concepts that have made Watkins Products, Inc. the world-wide leader in providing over 275 quality products direct to the home and farm." A giant Imitation Vanilla bottle sits atop this booth at the 1964–1965 World's Fair in New York.

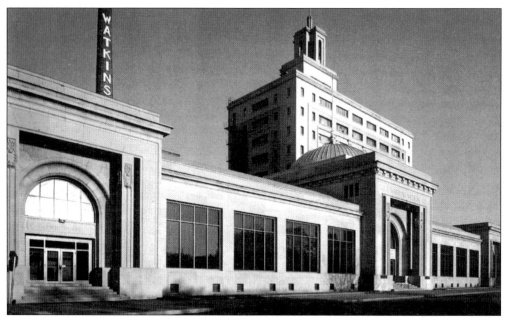

This recent postcard shows the Watkins buildings, standing today as they have since before 1920. The company still occupies the complex of buildings seen on the historic postcards, and the magnificence of the administration building is undiminished. The company produces some of the same products that made it successful many decades ago, while developing new products such as barbecue sauce. (Courtesy of Jim Bambenek.)

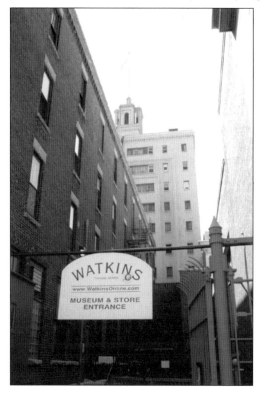

This photograph from 2003 looks down the alley behind the Watkins administration building. The sign is for the Watkins Museum, which contains a wide variety of Watkins photographs and historic artifacts, as well as a place to purchase items from Watkins' current product line.

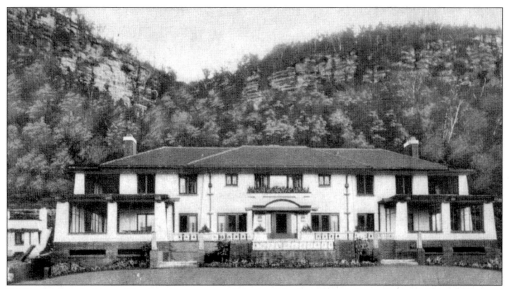

This postcard shows Rockledge, a mansion in Homer downriver from Winona. It was designed as a summer home for businessman E.L. King, whose wife Grace was the daughter of J.R. Watkins. The architect was George W. Maher, who designed buildings in Winona, Gary, Indiana, and elsewhere. He was a colleague of Frank Lloyd Wright.

This photo postcard shows Rockledge with its outbuildings and the bluff looming up behind it. After a long period of alteration, decline, and abandonment, the home was demolished in 1987–1988. Not all is lost, however: some of the structures on the grounds remain, and a few items such as cutlery and a chair are found in museums.

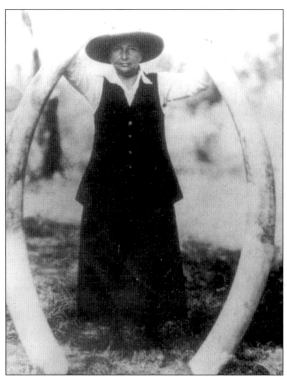

Grace Watkins, daughter of J.R. Watkins, was married to E.L. King and was a board member of the Winona National Savings Bank. She and her husband went on safari to Africa and India, and brought back trophies which were displayed at Rockledge and the bank. At one time, live lions were housed at Rockledge. She was named World's Champion Female Trapshooter in 1922. (Courtesy of American Trapshooters Association.)

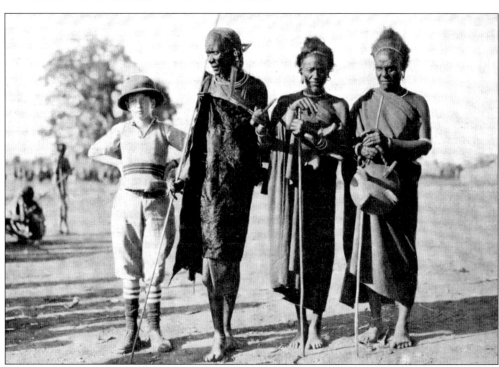

E.L. "Bud" King Jr. (the son of E.L. King and Grace Watkins) poses with three East African chiefs during one of the King family's safaris in Africa in the 1920s.

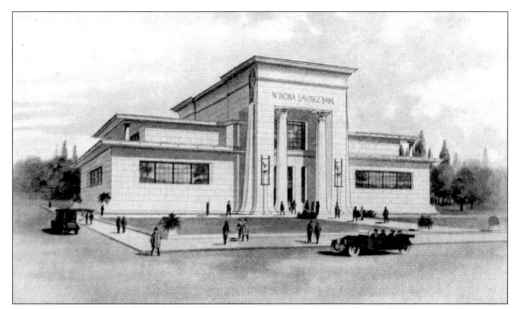

The Winona National Savings Bank, constructed from 1914 to 1916, was designed by George W. Maher. The design is in the unusual "Egyptian Revival" style, with elements of Beaux-Arts (the materials) and the Prairie School (Tiffany windows). The bank company itself had been started in 1874. The upper floors feature a gallery of trophies from the E.L. King family safaris from the 1920s.

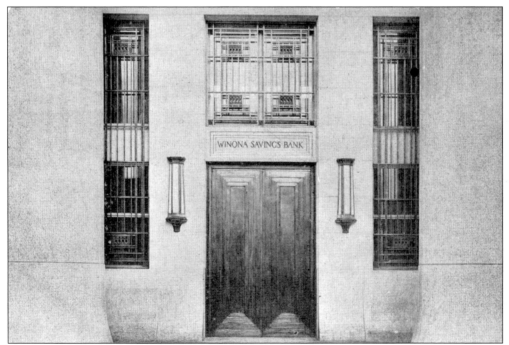

This postcard shows the entrance of the Winona Savings Bank, flanked by 37-foot granite columns which were quarried in North Carolina and polished in Vermont.

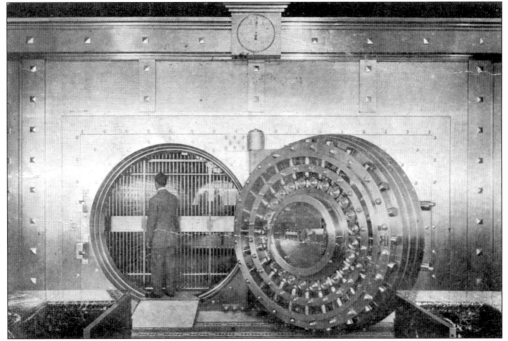

When this postcard was mailed in 1916, the bank paid four percent quarterly compound interest on all deposits. When you enter this bank, this massive shiny vault door is one of the first things you see; a conspicuous display of the bank's attention to security. This Diebold vault door is 22 inches thick, weighs 22.5 tons, and is constructed of 11 layers of steel.

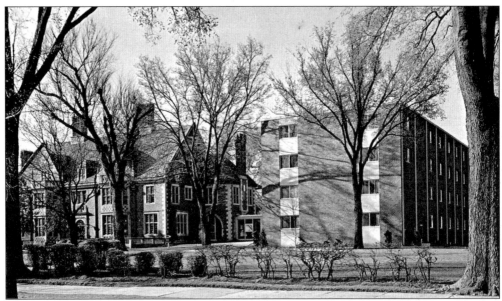

This mansion for Paul Watkins of Watkins Incorporated was lavished with a wide variety of fine construction materials. After Paul Watkins' death it became the Paul Watkins Memorial Methodist Home for senior citizens. Since 2002 it has been an assisted living facility operated by Winona Health. (Courtesy of Alf Photography.)

Nine
AROUND TOWN

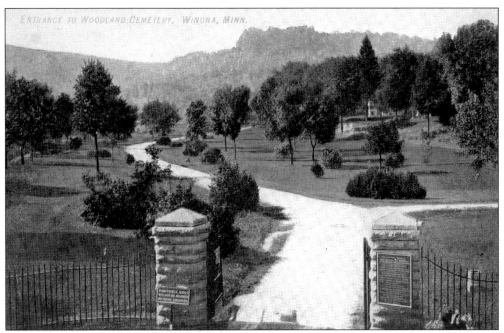

This postcard mailed in 1908 shows Woodlawn Cemetery, near Garvin Heights Road and the south end of Huff Street. Just west of Woodlawn Cemetery is Star Bluff, which once had a star-shaped memorial marking where an Indian woman fell off her horse and died.

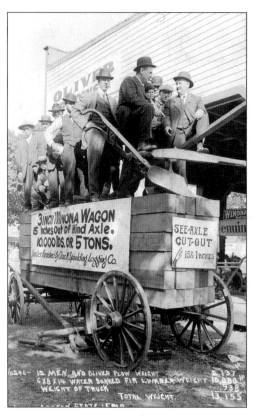

The Winona Wagon Company was started by A.J. Stevens in 1867 in Rushford (southwest of Winona), and moved to Winona in 1879 after the factory burned down. This company produced as many as 10,000 wagons a year. Two of the wagons built by the company are found in the Winona County Historical Society museum. The wagon in this postcard was photographed at the Oregon State Fair.

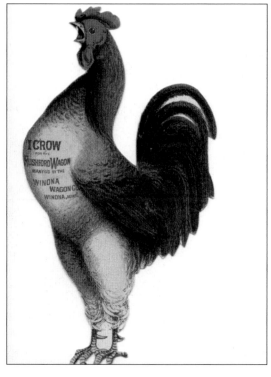

This advertisement cut in the shape of a rooster is an example of a Victorian trade card, a type of paper collectible that was popular before the postcard era. It advertises the Rushford Wagon built by the Winona Wagon Company. The company factory was located at 1009 West Fifth Street.

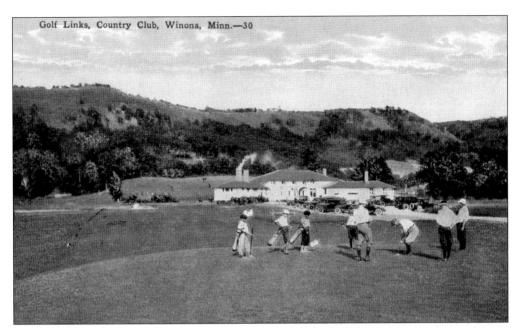

The Winona Country Club was started in 1896 by A.B. Youmans. Their new course was completed in 1919, and the clubhouse in Pleasant Valley was designed Tom Bendelow, a Chicago golf architect.

The fishing pier shown in this postcard from the mid-1970s is off the Huff Street causeway north of the visitor center. It juts into the eastern part of Lake Winona. (Courtesy of Dick Swift.)

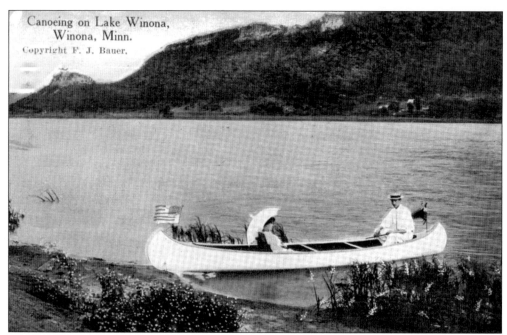

This postcard from 1914 shows George Cutler seated (at right) in a canoe. Cutler was a postcard publisher in his own right, once braving 14 rattlesnakes to get a good photograph of Indian Head near Fountain City.

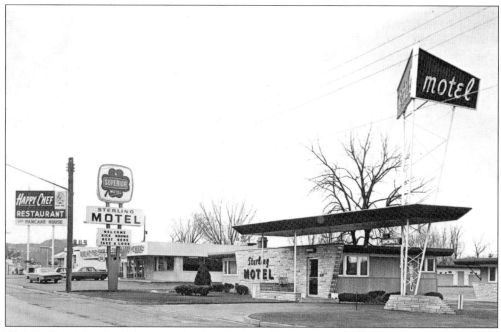

The Sterling Motel, still in operation on Gilmore Avenue near the Service Drive intersection (next to the Happy Chef), was one of Winona's first motels. (Oliver Durfey Collection, Courtesy of the Winona County Historical Society.)

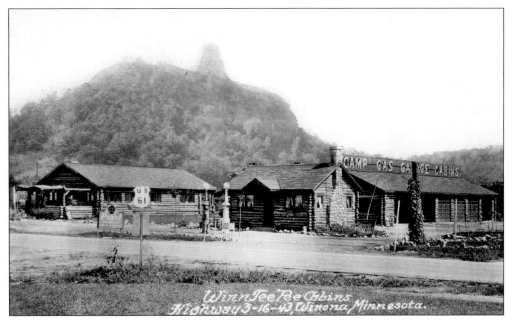

The Winn Tee Pee Cabins were located on the southeast corner of the city, across Mankata Avenue from the Hot Fish Shop. Around the time this postcard was printed, cabins cost between $1.50 and $6.00. Amenities included an elaborate log-cabin lodge with a stone fireplace.

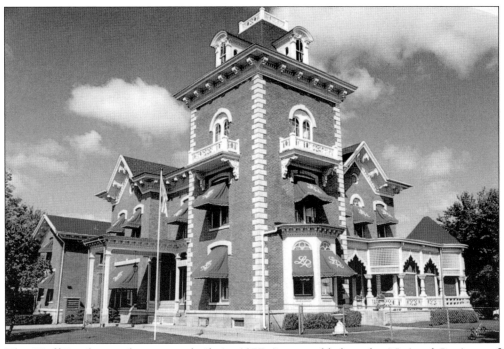

The Huff-Lamberton house was built in 1857. It was added to the National Register of Historic Places in 1976. Located on Huff Street, it is now a retirement home.

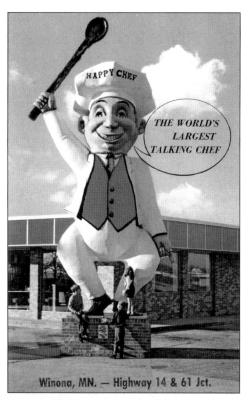

THE WORLD'S LARGEST TALKING CHEF

Winona, MN. — Highway 14 & 61 Jct.

This statue stood in front of the Happy Chef restaurant on Winona's west side. If you pressed the button in the pedestal, a recorded message from the Chef played from a speaker in the end of his spoon. The statue was eventually removed and replaced with a flagpole, and the restaurant was sold in 2003 after many years of service.

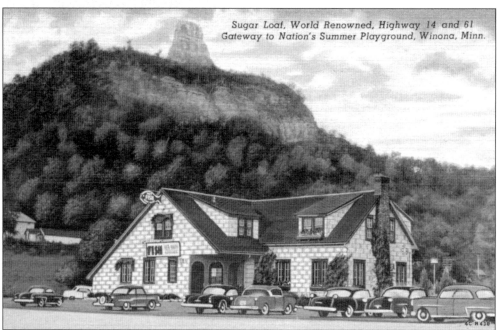

Sugar Loaf, World Renowned, Highway 14 and 61 Gateway to Nation's Summer Playground, Winona, Minn.

The Hot Fish Shop, which has been Winona's most renowned restaurant, opened in 1931 at the present site of the W-K elementary school, moving to the location near Sugar Loaf shortly afterwards. It was started by Henry and Helen Kowalewski.

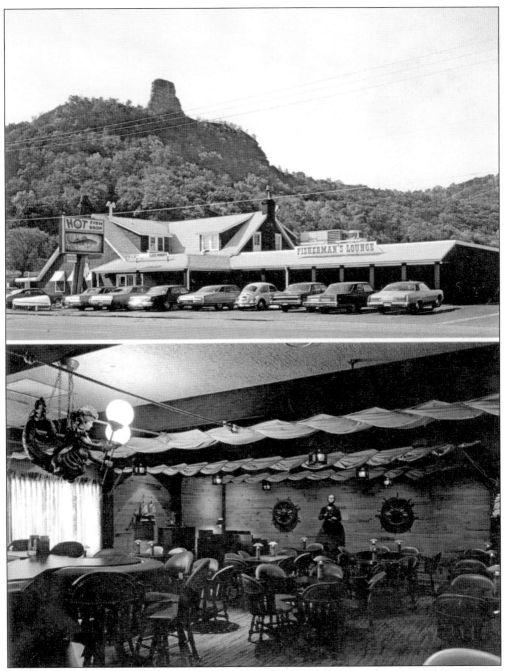

This 1970s postcard of the Hot Fish Shop is an unusually large one (the size of two postcards stacked). Items on the menu in the restaurant's last years included walleyed pike (including a walleyed pike sandwich), batterfried shrimp, catfish sandwich, and other seafood and beef entrees. The restaurant closed in 1999, and the site is now occupied by a Dairy Queen. (Courtesy of Winona Printing Company.)

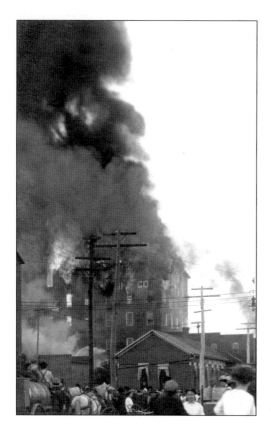

These two postcards are among several published from photographs of the July 28, 1911, fire at Bay State Milling. This fire caused hundreds of thousands of dollars in damage, and destroyed the flour mill and elevator (along with thousands of tons of wheat and flour).

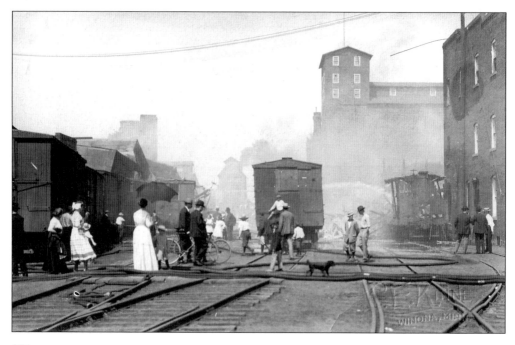

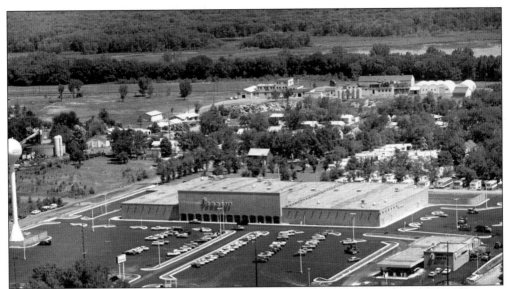

This J.C. Penney store located in Goodview at the Winona border opened in 1971. It featured groceries along with auto service and the typical Penney department store hard and soft lines, in a pioneering attempt at the sort of "superstore" now made popular by the Wal-Mart and Meijer companies. The current Penney store, now much reduced, shares this building with Econo-Foods. (Courtesy of Alf Photography.) Paul Miller, father of co-author Chris Miller, managed this store.

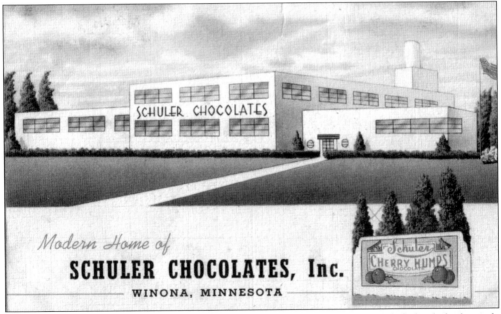

The Schuler company started as a bakery early in the 20th century, and the baked goods quickly gave way to ice cream, and then to candy. This postcard shows the plant constructed in 1941. Some of Schuler's candy products were Wingold, Sweet Secrets, This and That, Duck Lunch, Sugarloaf, Cherry Hill, and the famous Cherry Humps (which were continued for a time by the Brock company).

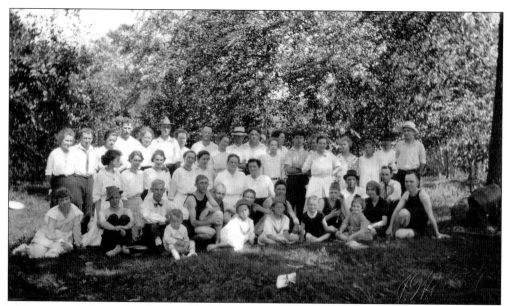

This postcard shows the August 1917 company picnic for the Jones and Kroeger Printing Company. George Engstrom, father of co-author Mary Pendleton, is sixth from the left in the back row. The company, which printed books and postcards, was located at 116 West Third. It was noted for fine printing and binding. They are currently in business as J & K Office Products (across the street from the old location).

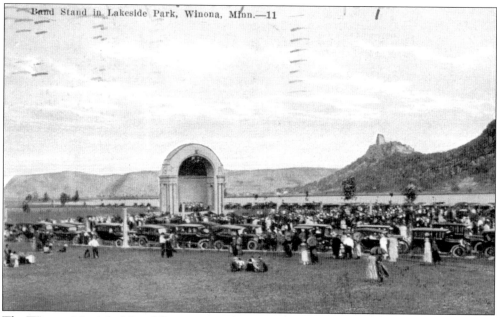

The Winona Municipal Band first organized in 1915. This postcard shows the band playing at the concert dedicating the new band shell at Lake Park in 1924. The Winona Municipal Band is the oldest municipal band west of the Mississippi.

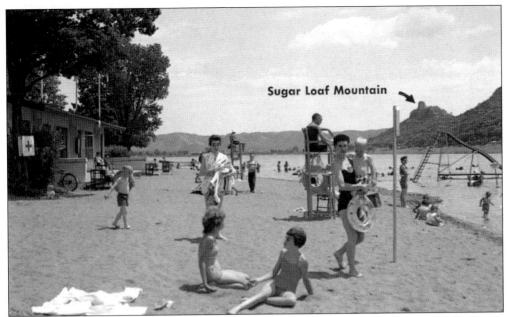

This postcard shows the beach at Lake Park on Lake Winona. After the Latsch Beach closed, the city encouraged swimming and sunbathing at the Lake Park Beach. Now, with the Lake Park facilities removed, Winona encourages swimming at the Aquatic Center water park. (Courtesy of the G.R. Brown Postcard Company.)

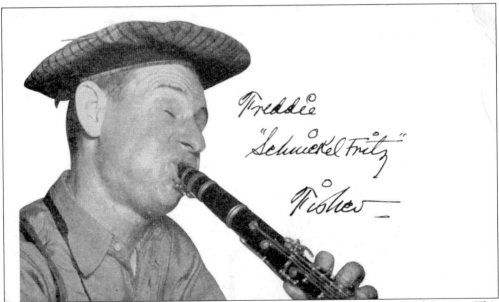

Freddie "Schnickelfritz" Fisher's band was the house band at the Sugar Loaf Tavern. This music-and-comedy band eventually ended up in Hollywood, where they made a few short films. They also played in New York City, and Aspen, Colorado, and also recorded "78" record albums on the Decca record label. Their songs included the "Winona Waltz" and the "Sugar Loaf Waltz."

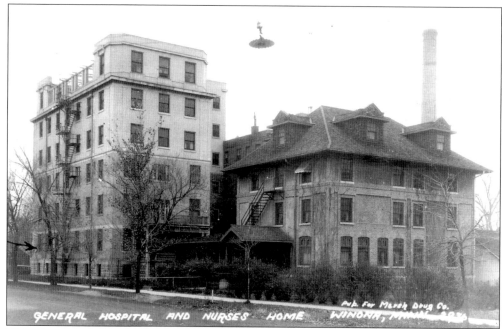

This photo postcard shows the Winona General Hospital and Nurses' Home. Mailed in 1938, it shows a back view of the hospital with the six-story tower section still under construction. The main building is out of view. The writing on the back reports that Lill is progressing fine. The arrow drawn on the left edge points to Lill's room. In 1962, the General Hospital was replaced with Community Memorial Hospital on Mankato Avenue.

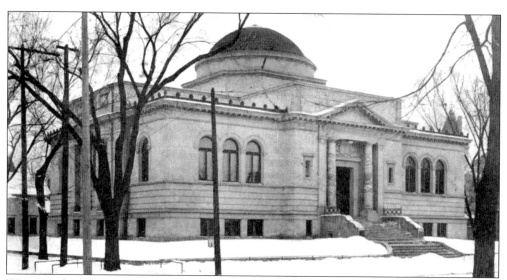

Winona's first library was established in 1857. The current building, on the corner of Fifth and Johnson, was built in 1899 as a gift to the city by lumber baron William Harris Laird. The architects were Warren Powers Laird (nephew of the donor), Edgar Seeler, and Cass Gilbert. It was built of gray Bedford stone and has a copper dome. The stack area is notable for its glass floors.

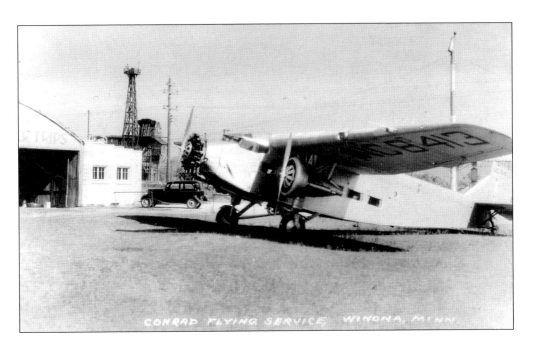

CONRAD FLYING SERVICE, WINONA, MINN.

Max Conrad, one of the greatest small plane pilots ever, was born in 1903 in Winona. He spent more than 50,000 hours in the air and broke many records. When Winona's airport was dedicated as Max Conrad Field in 1961, President John F. Kennedy proclaimed: "I'm happy to learn of the dedication of Max Conrad Field in Winona, Minnesota. Your numerous long range flight records in small aircraft are a tribute to your courage and professional ability. You have helped to prepare young people for the complex and serious responsibilities in the aerospace age. In addition, your work and example have brought good will to many parts of the world."

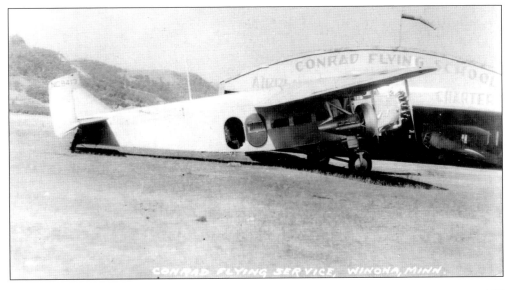

CONRAD FLYING SERVICE, WINONA, MINN.

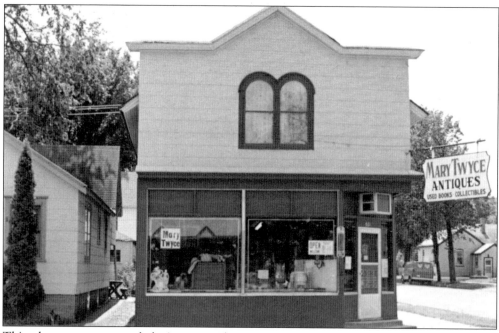

This chrome-era postcard depicts co-author Mary Pendleton's antique shop called "Mary Twyce." It opened in 1969, at 601 W. Fifth Street, and later moved across town to 601 E. Fifth Street, across from St. Stan's. Over the years, Mary has sold antiques, books, and paper collectibles, and, of course, postcards.

Radio Station KWNO

This will verify your report of reception of KWNO

on 3/8 _____ 1938

Maurice Reutter
Chief Engineer

250 Watts——1200 Kilocycles——W. E. Equipment

• WINONA RADIO SERVICE •

WINONA, MINN.

KWNO, now the AM radio flagship of the Winona Radio company, began broadcasting in Winona in 1938. This is a QSL card (a special kind of postcard mailed to radio station listeners) from the station's first year of operation. It was mailed by the chief engineer to a listener in Hornell, New York: implying that the radio station was heard 716 miles away.

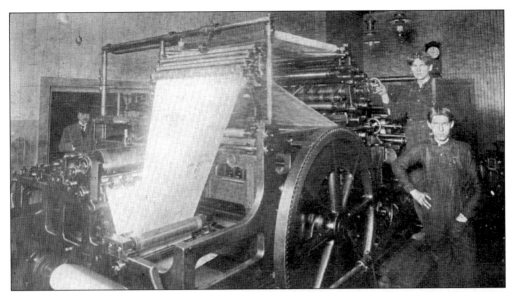

What is now the *Winona Daily News* began as the *Winona Republican*, first published in 1855. The paper became the *Winona Republican-Herald* in 1901, a name it kept until 1954 when it took on its current name. This postcard was sent in 1914 to a subscriber in Faribault to acknowledge a $3 subscription payment. The *Daily News* has a small museum that includes a linotype, but no large printing machine as shown in this view.

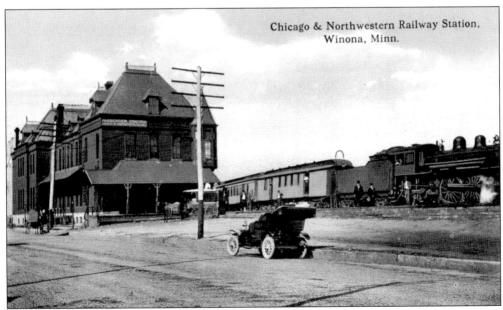

This postcard was made of a 1905 photograph of the Chicago and Northwestern Railroad Depot. This depot, located near the river front west of the bridges, was built in 1880.

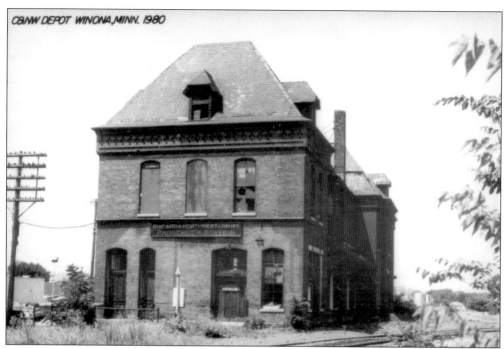

With the decline of the railways, the Chicago and Northwestern Depot fell into disrepair, and the corner towers were removed. The building was demolished in 1980 (100 years after its construction).

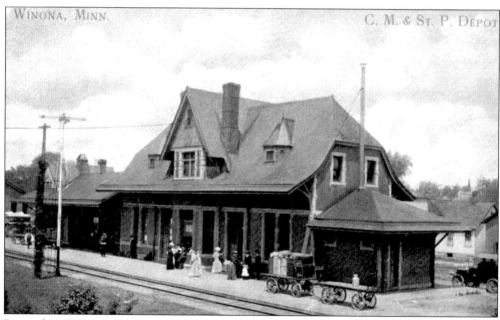

Located on East Mark Street, the Chicago, Milwaukee, and St. Paul (Milwaukee Road) depot is the only original depot left in Winona. Amtrak stops here daily (the Empire Builder), and the station is also used by Canadian Pacific, the freight railway that is the successor to the railroad system commonly known as the Milwaukee Road.

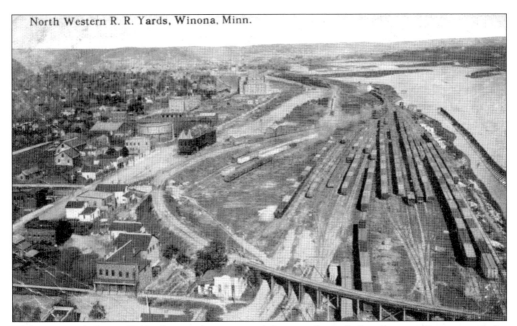

North Western R. R. Yards, Winona, Minn.

This postcard from 1913 shows the vast and busy rail yard that lay to the west of the Mississippi bridges. The Chicago and Northwestern Depot (1880–1980), which was on the intersection of Huff and Second, is seen above and to the left of the center (look below the word "Winona" in the title). Riverview Drive now runs through this area.

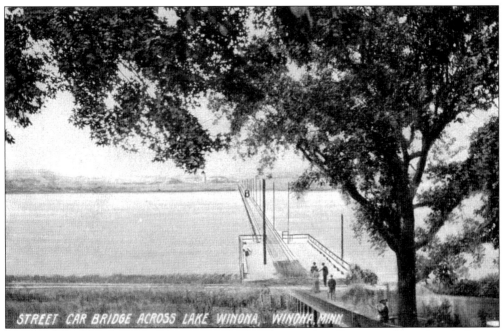

STREET CAR BRIDGE ACROSS LAKE WINONA, WINONA, MINN.

Winona's streetcar company ran a second bridge across Lake Winona to the area at the base of the Garvin Heights road. It was west of the main bridge across the lake. Films were shown at the Garvin Heights end in order to entice people across the bridge. The streetcars were eventually replaced by buses, and this bridge is long gone.

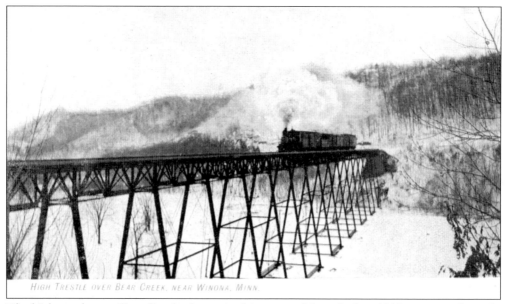

HIGH TRESTLE OVER BEAR CREEK, NEAR WINONA, MINN.

The high trestle over Bear Creek, shown in this postcard from before 1910, was torn down in the 1930s, and only abutments remain.

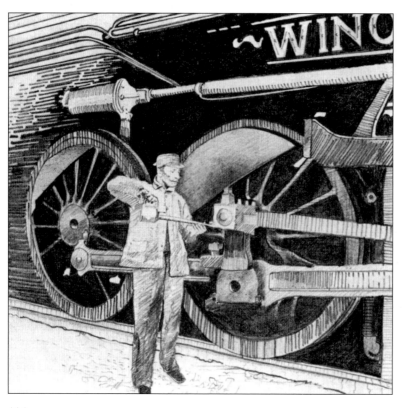

This artwork of engineer John Benson maintaining a locomotive was created by John Durfey (son of postcard photographer Oliver Durfey) for the Winona County American Bicentennial Calendar. (Courtesy of John Durfey.)

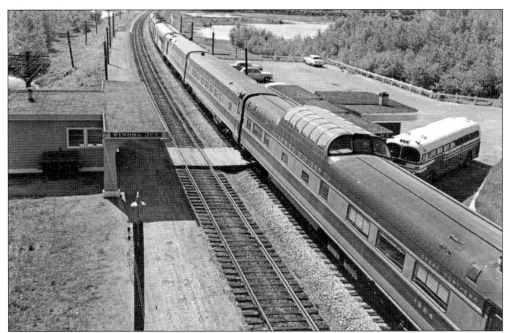

One of a few Winona Junctions that have existed in the area over the years, the Winona Junction depicted in this postcard view from June of 1958 was just east of Winona on the Wisconsin side. The "Empire Builder" stopped here and a bus was provided to take passengers across the Interstate Bridge into Winona. (Donald E. Smith Collection, Courtesy of Audio Visual Designs.)

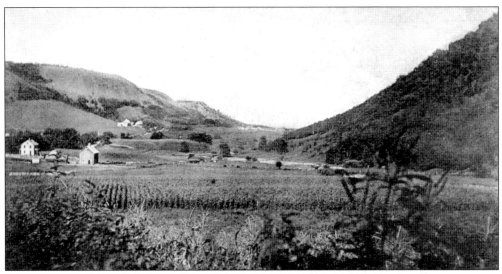

West Burns Valley, which leads from right behind (south) of Sugar Loaf to the west, was a region of dairy farms, brickyards, and breweries (including Schellhas and also the brewery that became Bub's, which was originally located behind Sugar Loaf). This postcard view of the valley is *c.* 1910.

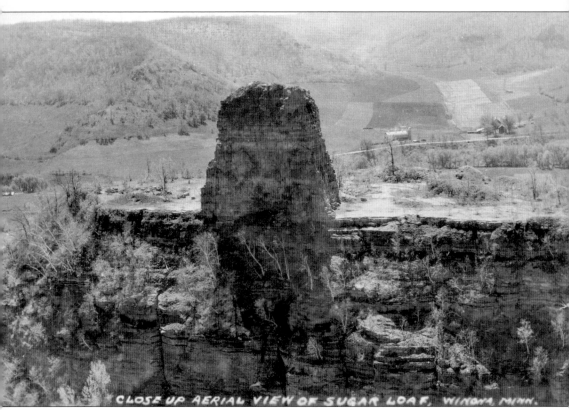

CLOSE UP AERIAL VIEW OF SUGAR LOAF, WINONA, MINN.

This photo postcard, likely from the early 1940s, depicts the top of Sugar Loaf and the valley behind the hill to the south. The valley is along East Burns Valley Road, one of the earliest paved roads in Minnesota. The barn, to the right of the rock tower, is now the site of Big Valley Ranch, and the Valley Oaks Subdivision is nearby as well. The plateau of Sugar Loaf is reached by a hiking trail from the west, and provides an excellent view of eastern Winona.

Eight months old at the time of this photo in this postcard, First Secretary (1973–1993) was the first offspring of the great race horse Secretariat and was sired upon an Appaloosa mare. He was born at Sahaptin Farm, atop the bluffs south of Winona, where he lived much of his life. His November birth made him ineligible for racing, but he sired 247 foals including many successful race horses. (Courtesy of Mary Nankivil, Sahaptin Farm.)

Shemeta with newborn colt.

This recent advertising postcard is from Big Valley Ranch, which is located in East Burns Valley behind Sugar Loaf Mountain. This farm was first built in 1914.

This postcard shows the architect's depiction of the yet-to-be-built St. Anne's Hospice, a 170-bed nursing home for the aged and for the chronically ill that opened in 1961. It was started by the Sisters of the Third Order Regular of Saint Francis, Congregation of Our Lady of Lourdes, Rochester, Minnesota.

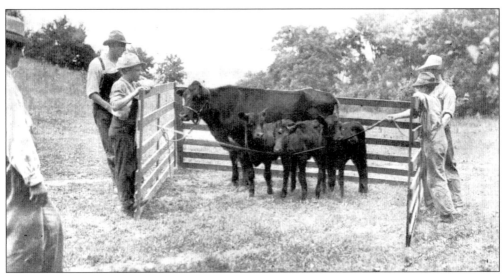

Shown on this postcard are three farmers at the John Zenk and Sons Farm, along with triplet calves which were born on March 12, 1912. The Zenk farm was started in 1852 by George Wallace. In 1885, John Zenk contributed a statue of the Sacred Heart valued at $125 to St. Joseph's Church in Winona.

Ten

NEARBY TOWNS

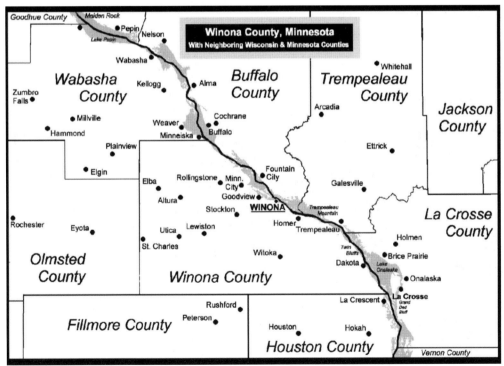

This map shows Winona County and the Mississippi River valley area from Maiden Rock, Wisconsin, south to La Crosse, Wisconsin.

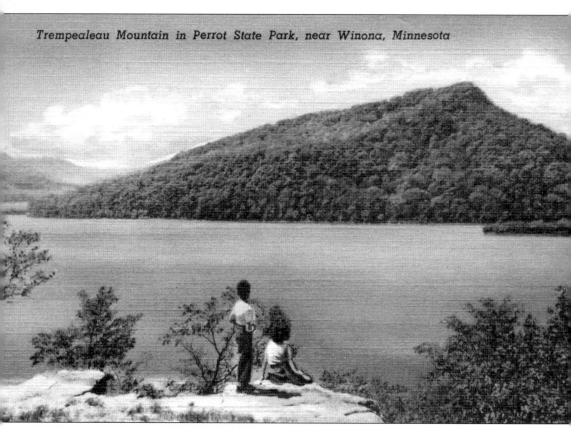

Trempealeau Mountain in Perrot State Park, near Winona, Minnesota

Mark Twain wrote of this bluff in *Life on the Mississippi*: "Trempealeau Island, which isn't like any other island in America, I believe, for it is a gigantic mountain, with precipitous sides, and is full of Indian traditions, and used to be full of rattlesnakes." The snakes, if they ever really left, have returned. Visitors to Perrot State Park are warned to stay off the mountain in August as the rattlesnakes are shedding at that time and can be particularly irritable.

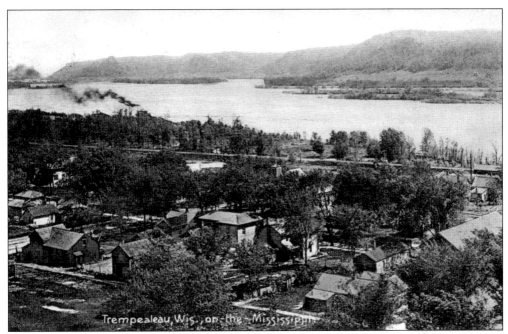

Before the white men came, the Trempealeau area was used as a camp by the Keoxa (Winona) band of the Dakota. The town of Trempealeau was started in the 1840s as Reed's Town, and consisted of a few cabins near James Reed's log house. Other names the town had included Montoville and Reed's Landing (which is not to be confused with Read's Landing upriver). This postcard from 1911 shows the rooftops of Trempealeau and the Mississippi River.

Rollingstone, which is located to the northwest of Winona, was settled in the mid-1850s by settlers from Luxembourg. The Holy Trinity Parish of the Diocese of Winona is based out of Rollingstone to this day. This postcard from 1910 depicts the church building, which was constructed in 1869.

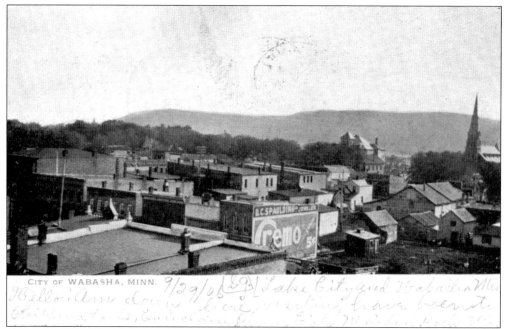

CITY OF WABASHA, MINN. 9/29/06 [29] *Lake City and Wabasha Wis*
Hello: Am down here visiting have been to
[handwritten text]

Wabasha, seen in this postcard from 1906, is Minnesota's oldest white settlement. It was founded in the 1830s as a fur post by Augustin Rocque, who was a nephew of Chief Wapasha II. Rocque's settlement had the name Cratte's Landing before being changed to Wabasha in 1843. This small town is now known nationwide as the location of the *Grumpy Old Men* movies, and is a place for watching bald eagles.

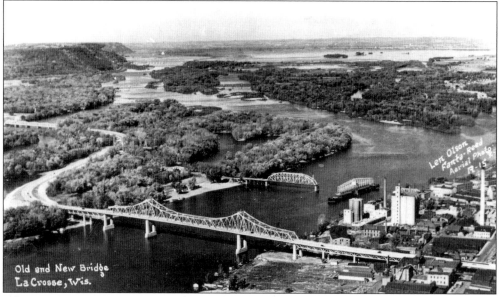

Old and New Bridge
La Crosse, Wis.

White settlement of La Crosse began in 1841. Previously, Winnebago Indians had lived in the area. The city is named La Crosse because traders in the 1700s saw the natives playing the game lacrosse (stickball) in the vicinity. Chief Wapasha II lost his eye playing this game. This air view, looking up the valley toward Winona, is from November 1942.

122

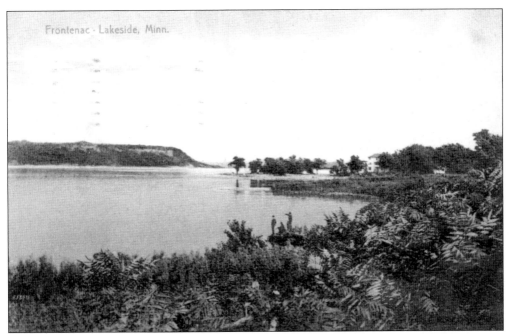

Frontenac in Goodhue County actually consists of two communities: Old Frontenac (founded in 1839, and now on the National Register of Historic Places) and New Frontenac. Mark Twain described it as a "delightful resort of jaded summer tourists." This postcard from 1909 shows the Lakeside Hotel area to the right.

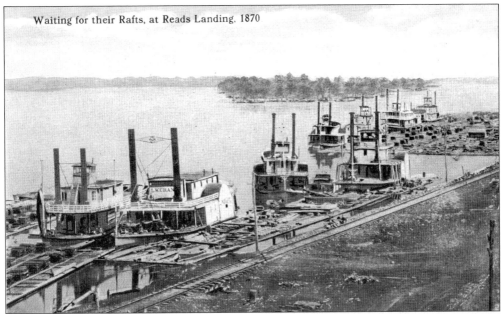

Read's Landing started out as a Dakota (Sioux) trading post. The post was first occupied from about 1800 to 1830 by Augustin Rocque, who was related to the Wapasha family. An English soldier named Charles Read bought it in 1847. This vintage postcard reprints a much older photograph from 1870 showing Read's Landing at the height of the steamboat era.

Lake City, Minn., 1867.

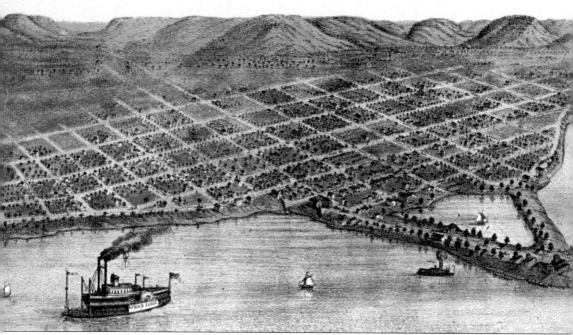

Lake City was first settled in 1853 by Jacob and Philip Boody, and was incorporated in 1872. Located in the middle of the western Lake Pepin shoreline, it is across the lake from the town of Pepin and the setting of Laura Ingalls Wilder's *Little House in the Big Woods*. In 1922, Ralph W. Samuelson made Lake City the birthplace of waterskiing. Maiden Rock in Wisconsin is a landmark always visible from Lake City's shoreline. Mark Twain referred to the area's "majestic domes, the mighty Sugar Loaf, and the sublime Maiden's Rock." This postcard from the 1910s shows an aerial view from 1867. The steamboat *War Eagle* is in Lake Pepin, and Sugar Loaf is the bluff on the far right.

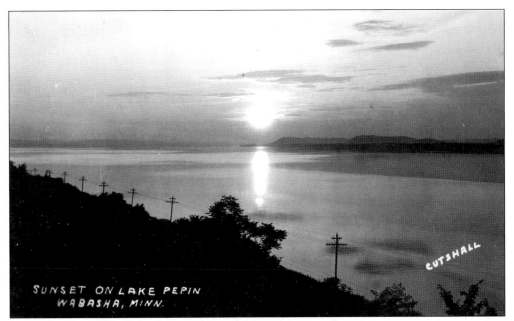

SUNSET ON LAKE PEPIN
WABASHA, MINN.

CUTSHALL

From the Pierce County Herald, July 16, 1890: "[Lake Pepin] is about 30 miles in length and 3 miles in width and owing to the high bluffs on either side which seem to confine the force of certain windstorms it is often transformed into an Atlantic fury. Old rivermen understand this and often wait for storms to exhaust themselves before venturing into its waters." It is located between Wabasha and Lake City, and Maiden Rock overlooks its Wisconsin shore.

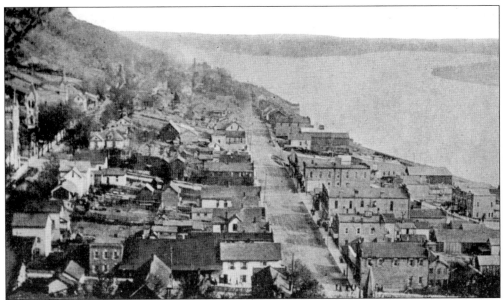

Fountain City lies a few miles northwest of Winona, on the Wisconsin side of the Mississippi River (north of Goodview, Minnesota). In *Life on the Mississippi*, Mark Twain quotes his fellow riverboat traveler: "Ten miles above Winona we come to Fountain City, nestling sweetly at the feet of cliffs that lift their awful fronts, Jovelike, toward the blue depths of heaven, bathing them in virgin atmospheres that have known no other contact save that of angels' wings."

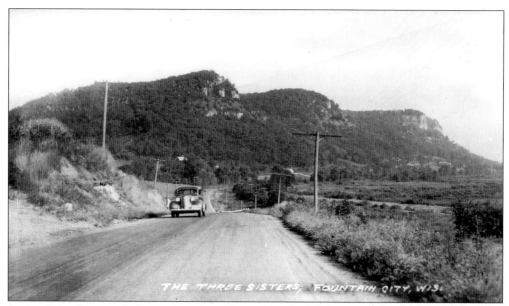

Located northwest of Winona on the Wisconsin side of the Mississippi River, the Three Sisters bluffs are between Fountain City and Bluff Siding. They are no longer marked or remembered on maps, but they are easily seen from Winona. Located atop the Three Sisters is the Mar-Jes View dairy farm, which has been in the same family since 1894. It is now open to tourists as "Room to Roam Farm."

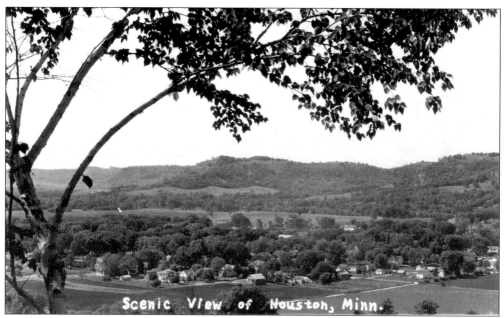

Houston is located in the Root River Valley, 25 miles south of Winona. A bluff north of town has the town's name spelled out on it, first put in place by the Civilian Conservation Corps in the 1930s. Houston was originally platted in 1852 by a settler who served under Sam Houston in the Mexican-American War.

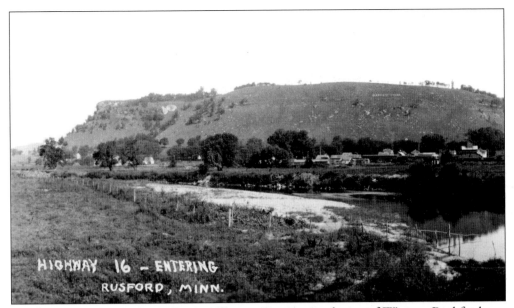

Located in the Root River Valley in Fillmore County, southwest of Winona, Rushford was founded in 1854. The Winona Wagon Company started in Rushford, and moved to Winona after a devastating fire. The railroad depot built in 1867 remains a historic landmark.

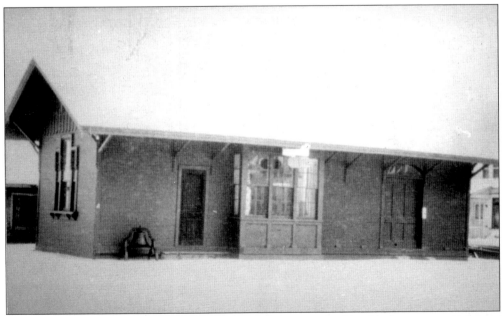

Peterson is located near Rushford. The railroad depot seen in this old photo postcard is now the Peterson Station Museum, featuring a large collection of historical items from the Peterson area. The railroad tracks have been converted to the Root River Bike Trail, a popular recreational attraction in southeastern Minnesota. This building has been moved and is no longer near the trail where the tracks used to run.

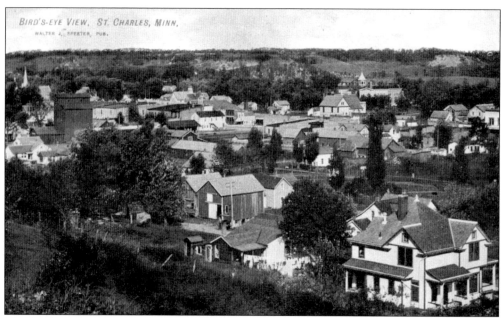

St. Charles was founded in 1854 in the Whitewater Valley, west of Winona. It was connected to Winona by rail ten years later. Whitewater State Park is a nearby attraction, and the Winona County Fair is held here every year in July. This community of 3,500 is at the western edge of Winona County's farm country.

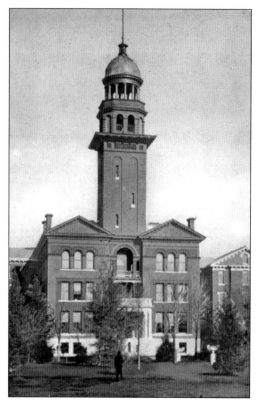

The state hospital at Rochester, west of Winona, served the mental health needs of the population of southeastern Minnesota, including Winona. It was built on the Kirkbride plan, which specified a symmetrical building with L-shaped wings and a large center section (shown in this vintage postcard). This institution is long since demolished. Rochester is also the home of the world-famous Mayo Clinic.